R.V. Katz, DMD, PhD
Professor
Department of Behavioral Sciences
and Community Health
UCONN Health Center

HAITIAN VODOU FLAGS

Folk Art and Artists Series
Michael Owen Jones
General Editor

Books in this series focus on the work of informally trained or self-taught artists rooted in regional, occupational, ethnic, racial, or gender-specific traditions. Authors explore the influence of artists' experiences and aesthetic values upon the art they create, the process of creation, and the cultural traditions that served as inspiration or personal resource. The wide range of art forms featured in this series reveals the importance of aesthetic expression in our daily lives and gives striking testimony to the richness and vitality of art and tradition in the modern world.

HAITIAN VODOU FLAGS

Patrick Arthur Polk

University Press of Mississippi Jackson

This book is dedicated to Jeri Bernadette Williams,
my wife, partner, and buddy,
and to Barbara J. Polk, my mother

Illustration and photo credits: Ron Battle,
figures 3–10; Odette Mennesson Rigaud, figure 2;
Jorge Rosemberg/AG 3, plate 3; Patrick Polk,
figure 1, plates 4–6, 18, 20, 25, 34, 37, and 45; Dennis
Nervig, photos courtesy of the UCLA Fowler Museum of Cultural History, plates 1, 2, 7, 10–14, 16,
22, 23, 29, 33, and 40; Susan Einstein, photos courtesy
of the UCLA Fowler Museum of Cultural History,
plates, 8, 9, 15, 17, 21, 24, 26–28, 30–32, 35, 36, 38,
39, 41–44, 46.

Library of Congress Cataloging-in-Publication Data
Polk, Patrick Arthur.
 Haitian Vodou flags / Patrick Arthur Polk.
 p. cm. — (Folk art and artists series)
 Includes bibliographical references.
 ISBN 1-57806-024-9 (cloth : acid - free paper).
 — ISBN 1-57806-025-7 (pbk. : acid - free paper)
 1. Voodoo flags — Haiti. I. Title. II. Series.
NK1678.V66P65 1997
704.9 ' 489967 — dc21
 97-14002
 CIP
British Library Cataloging-in-Publication data
available

CONTENTS

My interest in Vodou flags arose during my initial research trip to Haiti in late September 1991. On my first night in Port-au-Prince, I made the requisite pilgrimage to the Hotel Olaffson, where the bar was made famous by such luminaries as Graham Greene and Mick Jagger. The sweet, strong rum punch lived up to its reputation, but I was more taken with the colorful sequined flags hanging on the wall near the hotel's entrance, where guests with money to burn couldn't miss them. Made by the late Antoine Oleyant, one of Haiti's best-known flagmakers, the banners were lavishly sequined, strikingly beautiful, and definitely out of my price range. Although I had come to Haiti to collect folktales and legends concerning zombies, I decided that I would also spend some of my time learning more about the art of Vodou flagmaking.

However, the coup d'etat of September 29, 1991, which ousted Haiti's democratically elected president, Jean-Bertrand Aristide, altered my research plans, and I soon found myself back in the United States. Although I retained a strong desire to study Vodou flags after that abbreviated first trip to Haiti, I did not resume my research there until October 1994. By that time, President Aristide had been restored to power. I cannot adequately express the thrill I felt seeing him speak to the Haitian people from the steps of the presidential palace on my second day back in Port-au-Prince. During that excursion I had the good fortune to meet a number of prominent Vodou flagmakers, and a research project which had been put on hold quickly flourished.

This book would not have been completed if not for the encouragement, support, and assistance of many individuals. I thank professors Donald Cosentino and Michael Owen Jones of the UCLA Folklore and Mythology Program for encouraging my interest in Vodou flags and for guiding my work. I am also greatly indebted to Doran Ross, David Mayo, Owen Moore, Denis Nervig, and Fran Tabbush of the UCLA Fowler Museum of Cultural History for providing an opportunity to travel to Haiti and for facilitating the exhibit entitled *Sequined Spirits: Contemporary Vodou Flags*, which I curated for the museum. I also gratefully acknowledge additional support for research through the Arnold Rubin Award, administered by the Fowler Museum.

In Haiti, I would particularly like to thank the Vodou flagmakers Silva Joseph, Yves Telemak, Raymond Kasin, Joseph Fortine, and Edgar Jean-Louis for sharing their artistic vision with me and for their willingness to entertain my questions, no matter how ill informed, concerning the art of flagmaking. If not for them, this book would not exist. Furthermore, my research in Haiti would not have been possible without the expert assistance of Michel Maitre and George Rene. I am also indebted to Dr. Jacques Bartoli and Axelle Liautaud.

PREFACE

So there went the Ashanti one way,
the Mandingo another, the Ibo another, the Guinea.
Now each man was a nation in himself.
　　Derek Walcott, *Omeros*

the street's root is in the sea
in the deep harbours;
it's a long way from Guinea

but the gods still have their places.
　　Edward Kamau Brathwaite, *Sheperd*

That African peoples enslaved in the Caribbean during the colonial era were able to revitalize ethnic and national identities and to keep alive many of the traditions of their homelands in the face of brutal and dehumanizing social conditions is a remarkable triumph of the human spirit. Afro-Atlantic religions like Haitian Vodou, Brazilian Candomblé, and Cuban Santería clearly demonstrate the constancy of African religious thought and aesthetics within the context of exile and almost incomprehensible adversity. The dynamic rituals and rich forms of artistic expression which characterize these faiths offer believers vital sources of inspiration and liberation that even the most oppressive circumstances cannot shatter.

The means by which peoples of African descent maintained many of their religious traditions in the so-called "New World" is most commonly described by scholars as a process of creolization. In general, when members of two or more cultures enter into prolonged contact, either through vol-untary emigration or forced migration, new (creole) cultural patterns are formed as a result of their interaction. These emergent traditions draw, in varying degrees, upon the traditional practices of the cultures represented in the contact situation. Thus, in both its historical development and its contemporary practice, Haitian Vodou represents the active and thoughtful blending of African and European religious traditions.

Ritual flags (*drapo Vodou*), the most celebrated genre of Vodou's sacred arts, clearly reflect the creative impulse of Vodou and the intense process of cultural synthesis from which the religion emerges. Skilled flagmakers brilliantly combine and juxtapose African symbols with those of Europe and the Americas to form a mosaic of ritual art. Once little known outside of Haiti, drapo have become popular commodities in the international art market, and works by noted sequin artists such as Clotaire Bazile, Silva Joseph, Antoine Oleyant, and Yves Telemak now grace the walls of museums, art galleries, and private homes throughout the world.

In Africa, flags and banners have long been used to express notions of cultural identity, military prowess, and religious affiliation. Ceremonial flags are indispensable ritual objects in many African and Afro-American societies and, as a whole, represent one of the most significant artistic and ritual continuities within the Afro-

AFRO-ATLANTIC FLAG TRADITIONS

Atlantic world. The royal banners of Benin and the Fante Asafo military flags of Ghana (plates 1 and 2) encapsulate African nationality and social performance in much the same way as do drapo Vodou. In the Americas, the spirit-revealing drapo of Haitian Vodou have close counterparts in the regal standards used by Afro-Brazilian samba schools (*escolas de samba*) (plate 3) and in the Orisha flags of Grenada and Trinidad (plate 4), among others.

Although indigenous flag traditions may well have existed within the kingdoms and nations of sub-Saharan Africa before the age of European expansion, it was the introduction of European banners that stimulated the development of many African flag traditions. Most, if not all, African and Afro-American ceremonial flags exemplify the dynamic mingling of African and European military, political, and religious traditions which is a common trait of Afro-Atlantic cultures. Contact with the numerous European commercial, martial, and missionary organizations that established a long-term presence in Central and West Africa clearly stimulated both the ceremonial use of European flags and the production of localized banners. By the 1600s a wide range of flags were in use throughout the coastal regions and figured prominently in the military and courtly rituals of major African states. Ceremonial flag traditions flourished during the colonial occupation of Africa and many have continued into the

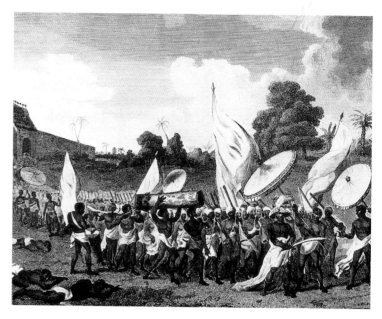

postcolonial era. The flags serve as a fundamental means of expressing relationships of power and authority and, as such, are integral components within the recognition and maintenance of political, social, and spiritual leadership.

While the historical documentation of the use of ceremonial flags within Afro-Atlantic societies is incomplete, evidence suggests that Africans and their descendants employed flags very early in the New World encounter. It is likely that flags were important symbolic objects within the many maroon communities established throughout the Americas. For example, after a Spanish attack on a fortified African encampment near Cartagena, Columbia,

This eighteenth-century illustration shows the use of flags in Dahomean military processions (Dalzel 1793).

8

in 1603, it was recorded that during the assault a "black lieutenant" defending the stronghold "died with the standard in his hands" (Thornton 1992: 86). Similarly, two centuries later (1826), Brazilian soldiers storming one of the numerous maroon settlements (*quilombos*) established in Brazil confiscated a red flag used by the quilombo's defenders (Reis 1993: 55). By the eighteenth and nineteenth centuries, Africans (both free and enslaved) and their descendants utilized flags for a variety of ceremonial and ritual purposes (plate 5). Today, it is evident that ceremonial flags continue to be vibrantly empowering symbols of spiritual and social unity within Afro-Atlantic communities.

The Sacred Universe of Haitian Vodou (The Lwa)

Vodou is the best known of the many Afro-Atlantic religions practiced throughout the Americas. Unfortunately, for most Americans, Vodou (usually spelled "voodoo") is virtually synonymous with witchcraft, black magic, and sorcery. The numerous low-budget horror films, pulp-fiction novels, and tales-from-the-crypt comic books which use "voodoo" as a main plot device have convinced many that Haiti is a land populated by evil witch doctors who create zombies and practice human sacrifice as part of their dark rituals. These images,

largely derived from American fantasies about blacks in general and Haitians in particular, are by no means accurate portrayals of the religion practiced by the majority of the Haitian people.

Like other African and Afro-American spiritual traditions, Vodou is an inherently practical religion, with its essence being the unending task of healing the sick, providing food for the hungry, securing work for the unemployed, finding love for the unloved. Initiates seek assistance in coping with the most pressing issues of daily life by invoking deities who have the power to make meaningful changes in the lives of their worshippers. For an adherent (*sèvitè*), Vodou offers an opportunity to better understand the world and a means of becoming more intimately involved with the divine beings who control it. In this way, the sèvitè can attain a state of spiritual harmony or balance (*balanse*).

The foundation of Vodou theology is the belief that the universe in inhabited by a diverse pantheon of deities (*lwa*) who serve as intermediaries between humans and God (*Bondye*). Even though he is the paramount spiritual force, Bondye is largely removed from the functioning of the cosmos and has no direct interaction with humankind. The governance of the realms of the sacred and the profane is left to the lwa, and it is they who control the fates of mortals. Fortunately, the lwa are acutely sensitive to the multitude of pleasures, sor-

9

rows, and surprising twists of fate that inform the human condition.

Through acts of devotion such as prayer, initiation, sacrifice, ritual music, and dance, Vodou priests (*oungan*), priestesses (*manbo*) and initiates (*ounsi*) establish close relationships with the representatives of the spirit world. Whether laborers in the crowded streets of Port-au-Prince or farmers in the rural fields of Haiti's Artibonite Valley, those who honor the lwa receive their blessings. Those who choose to ignore the gods have only themselves to blame in the event of sickness, unhappiness, and misfortune. The ability of the lwa to effectively address life's trials and tribulations is the supreme test of the religion's veracity. For those who live in poverty and for whom life is a day-to-day struggle to survive, as is the case for many if not most Haitians, the promises of gods and men must have impact here and now. Tomorrow may never come.

The legion of Vodou deities well represents the myriad African, Amerindian, and European cultures from whose combined spiritual traditions Haitian Vodou has emerged. The majority of the lwa honored and invoked in Vodou temples (*ounfò*) came from Africa (*Ginen*) and are often categorized as representing specific African ethnic groups (*nanchons*) such as Ibo, Kongo, Nago, or Rada. In many cases the names of the African ancestral deities revered in Vodou and the attributes ascribed to them have been altered by time and the harsh realities of the slave trade which stole their worshippers from their homes in Ginen. In Haiti, the African deities have been joined by the spirits of revolutionary generals, former Haitian statesmen, and powerful priests who, upon their deaths, were reborn as Vodou gods.

Vodou practitioners acknowledge several different ways of grouping the lwa, including by nation, by family, or by shared characteristics. At the most basic level the lwa fall into three categories: those who are cool (*fwet*) and soothing in nature, those whose personalities are hot (*cho*) and abrasive, and those who bridge the two extremes. Agwe, Danbala, Ezili Freda, and Lasirèn are among the cool lwa. Ogou and Ezili Dantò lead the hot lwa. The nanchons of lwa which most closely approximate the two polarities are Rada (generally cool) and Petwo (generally hot). Some lwa mediate the binary (hot/cool) principles of spiritual energy and are often listed by priests as belonging to both pantheons. The most notable of these are Bawon Samdi, Bosou, and Simbi. This dichotomy of hot and cool is central to the Vodou concept of spiritual equilibrium or balanse. Lwa with tranquil temperaments steady those with fiery dispositions; lwa with a soothing touch counter those with a heavy hand. Balance is struck.

Taken as a whole, the lwa are quite similar to the elaborate coterie of gods and

demigods who composed the pantheons of ancient Greece and Rome. The seductive Aphrodite who fired the passions of the Greeks finds her counterpart in the perfumed, silk-clad Vodou goddess Ezili Freda. The fury of Ares, warrior god of Rome, is well matched by the divine firebrand Ogou, who rallied a victorious army of slaves-turned-soldiers during the Haitian revolution. Like their Mediterranean peers, lwa are generally depicted in art and legend as anthropomorphic entities whose countless adventures form the basis of a complex mythology. The miraculous qualities of specific lwa, as well as their favorite songs, foods, colors, and dances, are common knowledge among Vodou practitioners. So, too, are their vanities and shortcomings. Initiates are confident that they can learn which lwa to turn to for assistance in any given situation and how to best approach them.

Among the many lwa are those associated with natural phenomena such as earthquakes, lightning, and wind. Vodou spirits inhabit the depths of the ocean, mountain streams, the recesses of the forest, and nearly every other part of the natural environment. Some deities preside over human endeavors such as agriculture, ironwork, and deep-sea fishing. Likewise, there are lwa who are responsible for matters relating to birth and death, sickness and health, wealth and poverty. Nothing in the cosmos exists apart from the gods.

The lwa can also be equated with the saints of the Catholic Church. Vodou practitioners themselves often make direct connections between the lwa and specific Catholic saints. The Ares-like deity Ogou, for instance, is frequently likened to St. James Major (Sen Jak). Colorful chromolithographs depicting the saint mounted on a warhorse and charging fearlessly into the midst of the enemies of Christ are found in almost all ounfò, and it is understood that they represent Ogou. Correlations are usually based upon similarities in the mythic attributes of specific saints and lwa and the sometimes amazing conjunctions in their artistic representations. Thus, the snake-like deity Danbala Wèdo is referenced by images of St. Patrick casting the serpents out of Ireland, while Azaka, master of agriculture, is depicted as the farmer-saint Isadore in murals on the walls of temples and in the designs of Vodou flags.

The sacred principles which the various lwa represent and aspects of their individual personalities are primarily made manifest through the actions of believers who are thought to be possessed by the gods during ceremonies. The phenomenon of spirit possession is the most prominent and perhaps the most misunderstood ritual aspect of Vodou. According to Vodou practitioners, when the lwa are invoked they travel from Lavilokan, the Vodou Mount Olympus, and enter into the bodies

11

of believers, displacing the souls or conscious personalities of their hosts. Individuals mounted by these divine horsemen, as the lwa are often called, remember little or nothing of their actions during possession and must rely on others to inform them of the results of their intimate encounter with the spirit world. Chosen to serve as vessels through which the sacred is channeled, possessed individuals become one with the lwa, and, in the dance, song, and speech which follow, they literally embody the ideals of Vodou theology.

Karen McCarthy Brown, anthropologist and Vodou initiate, relates the fundamental importance of spirit possession for the practice of Vodou: "These possession-performances, which blend pro forma actions and attitudes with those responsive to the immediate situation, are the heart of a Vodou ceremony. The spirits talk with the faithful. They hug them, hold them, feed them, chastise them. Group and individual problems are aired through interaction with the spirits. Strife is healed and misunderstanding rectified" (1991: 6). This passage, taken from the book *Mama Lola: A Vodou Priestess in Brooklyn*, sums up the close relationships that develop between humans and the lwa. When the gods descend, they invariably concern themselves with issues of this world, and they always interact with worshippers on a personal level. The lwa are understood to be family members in spirit form, divine ancestors.

Although the lwa are thought to be innumerable, in practice there are relatively few deities who are routinely honored in ceremonies and whose images regularly appear in Vodou's sacred art forms. Those most commonly invoked during Vodou services and depicted on Vodou flags are the following:

Agwe is the lord of the ocean. As protector of ships at sea, it is he who is responsible for successful voyages and safe return to port. Ships and fish are his special symbols. Agwe is occasionally associated with St. Ulrich, because the latter holds a fish in his hand in a popular chromolithograph. Offerings for Agwe and his consort, Lasirèn, are taken out to sea and placed in the water where they can sink down to the submerged palace in which the deities reside.

Ayizan watches over the manbo and ounsi of Vodou societies and presides over the instruction of new initiates. Described variously as the wife of Legba or of Loko, she is also the guardian of meeting places such as markets and public squares. Ayizan offers her worshippers protection against sorcery and malevolent magic. A strong mother-figure, she is reputed to be a powerful healer. Her main symbol is the palm leaf used during initiation ceremonies.

Azaka (Zaka) appears in the guise of the rural farmer wearing blue denim and a straw hat, carrying a knapsack in which he keeps his belongings. As the master of agri-

12

culture he is responsible for assuring successful crops and harvests. He is a hard worker with an insatiable appetite for the simple foods of the countryside, such as bread, corn, and sugar. Fond of smoking, he usually has a pipe close at hand. He is often depicted as St. Isadore, a farmer so devout that angels tilled his fields while he prayed.

Bawon Samdi, the guardian of the cemetery, is the paramount spirit of the dead. When he appears during ceremonies, he often makes obscene comments and gestures, performs a lewd dance (*banda*), and smokes cigarettes incessantly. He usually dresses like an undertaker, with a top hat, black coat, and dark glasses. His favorite offerings are black roosters and strong rum laced with pepper, and he prefers the colors black, red, and purple. Bawon Samdi is assisted in governing the realm of the dead by a horde of siblings known collectively as the **Gedes**. These include **Bawon Simityè**, **Bawon Kwiminel**, **Bawon Lakwa**, **Brav Gede Lakwa**, **Gede Nimbo**, and **Mazaka**.

Bosou takes the form of a powerful bull with two and sometimes three mighty horns. An ambiguous lwa who is alternatively hot and cool, he is associated with lightning, fertility, and protection from harm. Although Bosou possesses the healing touch, when he is provoked his ire is notorious, and there are few who care to feel his wrath. Some suggest that Bosou is one of the Vodou spirits whose aid can be "bought" and used for malevolent purposes. His colors are red, black, and white.

Danbala Wèdo and his wife, **Ayida Wèdo**, together represent the principles of birth and creation. The divine mother and father of the cosmos, they are usually depicted together as two serpents or as a serpent and a rainbow. Danbala is an especially popular deity and is often represented alone as St. Patrick or Moses. Those possessed by Danbala hiss and slither on the ground or climb up into trees or the support beams of ounfò, as mundane snakes would surely do. Eggs, trees, and water sources are sacred to Danbala and Ayida, and they prefer white or silver offerings.

Ezili Dantò, a fiery goddess, is usually depicted in Vodou arts as a black Madonna with child and is noted for her strong maternal instincts and stormy disposition. She is also a red-eyed warrior who strengthens the resolve of those in her charge and instills fear in the hearts of her opposition. She is the particular favorite of overworked and abused women, for whom she has great compassion. Her favorite colors are blue and red, but multicolored fabrics and patterns also please her. Worshippers offer her rum, black pigs, and strong cigarettes.

Ezili Freda, the cool counterpart of Ezili Dantò, is sweet, soothing, and the epitome of feminine beauty. A goddess of

13

love raised in the lap of luxury, she dances gracefully and flirts with each man she encounters, knowing full well that if he has not yet pledged his undying love for her, he soon will. Her symbols are blossoming flowers and ornate hearts. She prefers offerings of jewelry, perfume, liqueur, cake, and silk or lace. She is associated with the incarnation of Virgin Mary as Our Lady of Mount Calvary.

Gran Bwa, ruler of the forest, is the master of herbal remedies. He also presides over initiations which require, at least symbolically, the secrecy of the forest's darkest recesses. He normally appears as a tall, symmetrical figure that is half man and half tree. His Catholic counterpart is St. Sebastian, a Christian martyr who was tied to a tree and executed. Gran Bwa prefers flowers, leaves, and other offerings that reflect the verdant colors of the forests and woods he inhabits.

Lasirèn, wife of Agwe, is the queen of the ocean and the patroness of music. An enchantress from the depths of the sea, she surfaces to bestow her favors on those faithful to her. Lasirèn is usually depicted as a light-skinned mermaid with long flowing hair. Beautiful, talented, and vain, she holds a trumpet, mirror, or comb in her hand. Offerings of perfumes, seashells, mirrors, and white pigeons or doves are especially pleasing to her.

Legba is the guardian of the sacred crossroads and keeper of the gate that divides the sacred and mundane worlds. Vodou ceremonies always begin with an offering to him. The most popular song dedicated to him starts with the words "Papa Legba, remove the barrier, so that I may pass through." He is described as an aged, pipe-smoking man who moves slowly with the aid of a crutch or cane. Because he holds the "key" to the heavenly gate through which the lwa pass, he is often identified with St. Peter. His favorite color is red.

Loko is guardian of the ounfò, and it is he who oversees the initiation of priests. He walks closely with Legba and controls the temple's center pole (*poto mitan*) through which the lwa descend into the ounfò. Like Gran Bwa, he is associated with vegetation and is a master healer who guides the work of herbalists. Silk-cotton trees are especially sacred to Loko, and their branches are often draped with straw bags in which offerings to him have been placed.

Marasa, the divine twins, are the protectors of children. Human twins are thought to have particularly close spiritual bonds with the Marasa. Occasionally a third deity is linked with the Marasa, and the three are referred to collectively as the **Marasa Twa**, or sacred triplets. Feasts called *manje Marasa*, at which sacrificial foods are offered to the Marasa in return for their divine patronage, are held at various times during the year. In art, they are

normally represented by matching sets of dolls or images of the twin saints Cosmos and Damian.

Ogou is the paramount masculine spirit of the Vodou pantheon. He is the master of iron, the lord of battle, and the lwa who clears obstacles from the path of his worshippers. A powerful, crusading warrior, Ogou is the first to be invoked during conflicts and crises. He is frequently associated with St. James Major. Although his attributes are hot and hard, he also has the ability to heal. His special symbols are flags and swords, his sacred color is red, and his favorite offerings are rum and red roosters.

Simbi travels the watery realm of the ancestors and returns with powerful medicines. Closely related to Danbala, he is the patron of the rains and inhabits springs, lakes, and rivers. Although he is often sought out for his vast medical knowledge, Simbi is a shy and retiring lwa who prefers the solitude of his watery habitats. Those possessed by him frequently submerge themselves in ponds or rivers. White animals are offered to him as sacrifices.

The Ritual Use of Drapo Vodou

Most Vodou societies possess at least two flags (*drapo sèvis*) which represent both their congregation and the deities they worship. Although they are often beautiful works of art, drapo are important within Vodou primarily because they are powerful

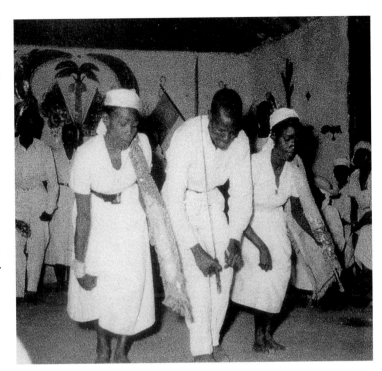

Vodou flag parade.

liturgical objects. When utilized in rituals, they exemplify not only the transcendent beauty of the lwa, but also the strength and power of the deities' active presence within the ounfò. Because of this, flags are among the most sacred and expensive ritual implements in the temple, and their presence is essential in most Vodou rites, including initiation, invocation of the lwa, and pilgrimage.

When called for during rituals, drapo are retrieved from one of the ounfò's shrine rooms by the Vodou society's (*sosyete*) swordmaster (*laplas*) and two or

15

three female initiates who serve as the flag-bearers (kò-drapo) for the sosyete. The members of the colour guard carefully unfurl the drapo and then charge back into the main chamber (peristil) of the ounfò, where they perform intricate manoeuvres with great pomp and circumstance. Sabre in hand, the laplas marches between the flags and directs the lively movements of the kò-drapo, thus creating one of the most dazzling spectacles in Vodou. Turning and wheeling with synchronized precision, they first salute the drums, the poto mitan, and the four corners of the peristil. They then salute all the dignitaries of sosyete, who salute them in return. Once the flags have been introduced and leading members of the congregation properly recognized, the laplas and kò-drapo return the flags to the shrine from whence they came.

While there are many lwa for whom drapo Vodou may be created, according to some Vodou priests the only deities who absolutely must have drapo sèvis dedicated to them are Ogou (plate 6) and Danbala (plate 7). Thus, many ounfò have only two drapo sèvis that are used in ceremonies. Temples with more substantial resources may have flags for several other deities in addition to those dedicated to Ogou and Danbala. When asked what lwa should have flags if circumstances allowed, the oungan/flagmaker Joseph "Boss To" Fortine provided the following list ranked in order of importance: Ogou, Danbala, Ezili Freda,

Gede, Loko, and Ayizan. In the best of all worlds, a society would possess flags for each of these lwa and would utilize them in the rituals associated with each.

In Vodou services, as is the case in military parades and reviews, drapo sèvis that are presented and carried through the temple are generally conceptualized pairs of two or sets of three. Ideally, drapo sèvis that are used together in ceremonies will have been made at the same time and from the same materials. It is generally thought that as long as they are in use, they should be kept together as a set. In practice, however, flags used as pairs are not necessarily of the same age and manufacture. Such a situation can arise for a number of reasons. For instance, one of a pair may wear out before its mate does. One of the pair may be stolen, accidently destroyed, or seriously damaged in some way. Economic factors may also work to separate pairs of flags. If, for example, a foreign art collector comes to the ounfò looking for flags but is interested in acquiring only one of a pair, the owner's need for the money the collector is willing to pay may outweigh his desire to keep the set intact.

Because many Vodou societies have or use only two flags, the most common type of flag ceremony is the two-flag presentation, or sèvis drapo de. As suggested above, the sets of flags used in two-flag services normally represent Ogou and Danbala (plates 8 and 9), although flags representing

16

Ezili Freda or Agwe are occasionally paired with that of Ogou. In every pairing of drapo sèvis, one of the two flags used is dedicated to Ogou and usually depicts his incarnation as Sen Jak. This is because Ogou is the lwa most closely associated with the Haitian revolution and struggle for independence. Therefore, he is generally viewed as the spiritual leader of the nation and a principle symbol of freedom and the military power which assured it.

The pairing of Ogou's banner with that of Danbala or Ezili Freda reflects Vodou's emphasis on the balancing of "hot" spiritual forces with "cool" ones. A flag dedicated to Ogou must be paired with one of a lwa who represents opposite or complementary energies. Thus, the hot and fiery Ogou is offset by cool and soothing deities, such as Danbala, Ezili Freda, or Agwe.

Although most ceremonies call for the use of two flags only, there are some services which may require the presentation of three drapo. These are referred to as three-flag services (sèvis drapo twa). According to the flagmakers Joseph Fortine and Raymond Kasin, the lwa most commonly represented in sèvis drapo twa are Ogou, Danbala, and Bawon Samdi or one of the other Gede lwa. In addition to being among the most popular and important Vodou deities, Bawon Samdi and the Gedes are also mediating spiritual forces. The incorporation of a flag honoring one of this family of spirits is a logical complement to

a pair of flags representing hot and cool deities. The importance of the equilibrium between the opposing principles governing the world of the living is highlighted by juxtaposing both to the otherworldly realm of the dead. Other occasions at which three flags may be deemed necessary are ceremonies specifically dedicated to Ezili Freda (sèvis Ezili). In this case, three different flags honoring Ogou, Danbala, and Ezili Freda may be presented to the society.

The additional expenses and more complex ritual maneuvers which accompany the use of three flags have prompted some Vodou societies and their flagmakers to devise a simple method of getting around the need for the three flags required in ceremonies such as the sèvis Ezili. Rather than make separate flags for Ezili Freda and Danbala, they instead set images of each side by side on one flag. In this way, deities possessing similar characteristics can be much more easily depicted and invoked. Thus, one pair of flags representing Ogou and Danbala/Ezili can be used for more general services as well as the sèvis Ezili (plates 10 and 11). The most common examples of this artistic and ritual economizing are the groupings of Danbala/Ezili and Danbala/Ezili/Agwe. The ritual association between Danbala and Ezili Freda has become so close that even flags specifically dedicated to one usually have some iconic reference to the other. For example, drapo for Ezili Freda often promi-

17

nently feature the serpents that represent Danbala (plate 12). Likewise, many flags honoring Danbala include the tracework heart of Ezili Freda.

The Main Elements, Types, and Styles of Vodou Flags

Ancient yet always up-to-date, Vodou has as its hallmark the ability to consolidate the emergent products of modern culture and seamlessly integrate them with the traditional symbols, values, and rituals of Africa. Born of the convoluted Creole society that was formed in Haiti during the era of the African slave trade, Vodou's sacred arts are largely derived from those of Central and West Africa, yet Vodou practitioners routinely incorporate images that originated in Europe and the Americas (Metraux 1971 [1959]; Bastide 1971; Cosentino 1995). Of the cultural melting pot that is Haiti, Donald Cosentino writes: "Have any people been confronted with a more heterogeneous repertoire of materials for spiritual reconstruction? Fragments of Africa, certainly, but also bits and pieces from the Taino, from Celtic and Enlightenment France, from the Jesuits and the Masons and all the emporia of twentieth century capitalism" (1995: 28). Flagmakers actualize this convergence of spiritual and visual traditions in their craft by weaving together African ritual designs, pictures of Catholic saints, Masonic symbols, images

from maritime lore, and innovative ideas taken from a wide variety of mystic and popular arts.

Although historical evidence is scant, it would appear that most Vodou flags used in the nineteenth and early twentieth centuries were constructed from one or two pieces of colored fabric with little or no ornamentation. Simple blue, red, or white banners decorated with embroidered images and perhaps a few metal bangles and glass beads served their ritual purposes well. They may not have been as artistically captivating as contemporary drapo Vodou, but this was not nearly as important an issue then as it is today. Because of the continued high cost and relative scarcity of decorative materials, many flags and banners used today in Haiti's rural areas still reflect the stylistic simplicity of the earliest flags.

In Port-au-Prince, where a fairly constant supply of sequins and beads is brought in from the United States and Canada, the great demand for lavishly embellished flags has helped to establish a number of highly skilled artists who specialize in the creation of these drapo. Supported by the tourist trade and upscale art galleries, these artists have taken Vodou flagmaking well beyond its traditional decorative boundaries.

The three principal artistic features or elements which characterize Vodou flags are the central design or motif, the field (the flag's background), and the border

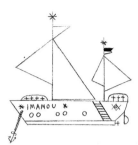

Vèvè for Agwe.

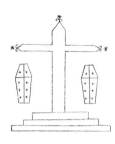
Vèvè for Bawon and the Gedes.

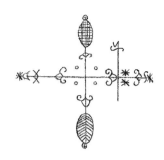
Vèvè for Legba.

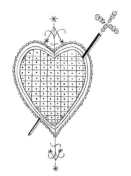
Vèvè for Ezili Freda.

Vèvè for Ogou Sen Jak.

Vèvè for the Gran Bwa.

which surrounds the field and central design.

The central motifs or images set on Vodou flags represent specific deities, spirits, or liturgical objects used in ceremonies. Because the flags are generally intended to honor and invoke gods as well as to depict their physical and metaphysical attributes, flagmakers strive to create works of art that present the visages and icons of the deities in dazzling displays of color. Decorated flags attract, enliven, and inspire deities and worshippers alike. From a purely artistic standpoint, Vodou flags are perhaps best thought of as low-budget stained glass. Shimmering with reflected light, they focus the attention of viewers on the beauty and grace of the spirits they represent.

The sources for the central motifs most commonly utilized on Vodou flags can be divided into three basic categories: ritual drawings (vèvè), Catholic chromolitho-graphs, and other images from popular culture.

Many, if not most, Vodou flags bear stylized renderings of the ritual designs (vèvè) that are used during Vodou ceremonies to represent and invoke the deities. Each principal lwa has his/her own signature vèvè—the ship of Agwe, the cemetery cross of Bawon Samdi and the Gedes (plate 13), the crossroads of Legba (plate 14), the pierced heart of Ezili Freda, the sword and banners of Ogou, or the strangely symmetrical outline of Gran Bwa. Derived from ritual ground drawings used in Central and West Africa, vèvè are used to consecrate ritual space. For this reason, their ornate scrolls, curls, and lacework patterns constitute the basic geometry of much of Vodou's sacred art. They can be traced on the ground with flour or chalk, painted on the walls of ounfò, or embroidered on drapo in order to bring forth divine energy.

Vodou drapo are also often embellished

19

with the colorful paper images (chromo-lithographs) of Catholic saints which are found throughout Haiti. Made in Italy, Mexico, and Spain, these portraits vividly depict the various saints and their icons. Because most of the African deities within Vodou's pantheon have been syncretized with Catholic saints, the chromolithographs have become a fundamental wellspring of inspiration for flagmakers. Some drapo Vodou feature simple embroidered outlines traced from the chromolithographs, while others display magnificent representations with each detail of the original painting faithfully copied with beads and sequins. Although a wide range of saints' images are used in Vodou, those most frequently featured on flags are St. Isidore (plates 15 and 16), St. James Major (plates 17 and 18), St. Patrick (plates 11 and 19), and incarnations of the Holy Virgin such as that of Mater Salvatoris (plate 39). These glittering silhouettes, perceived as both Catholic saints and African deities, powerfully reflect the multivocality of sacred symbols within Vodou.

Some drapo have primary central images whose usage cannot be traced to the influence of chromolithographs or vèvè. Most notable are images of the mermaid (siren) used on flags for Lasirèn. For Vodou practitioners, she is the embodiment of that fabled water spirit of maritime lore (plate 20). Although this is one of the lwa most commonly depicted on drapo Vodou, no direct antecedent for the image of the mermaid is found in the vèvè or Catholic chromolithographs used in ceremonies. Her presence in Vodou art is probably due to the incorporation of maritime lore and iconography as reflected in legends, ships' figureheads, and nautical charts. Tales of mermaids and mermaid-like spirits are common in Africa, and their artistic representations have clearly been patterned after European sources (Drewel 1996; Houlberg 1996). It is more than likely that the same process occurred in Haiti. Recent influences include travel brochures that use the mystique of the mermaid to lure tourists to seaside vacation spots.

As flagmakers expand their thematic range to take advantage of the ever-widening market for drapo Vodou, they increasingly look to other sources of inspiration in order to create unique images of the lwa. Yves Telemak, for instance, once turned to the pages of an adult magazine in search of the perfect image for a female spirit renowned for her lusty nature. The increasingly large number of non-Vodou practitioners for whom flags are produced has also had a significant impact on the types of images used on flags. During the 1994 U.S. military intervention in Haiti, an enterprising flagmaker began making flags which featured the official insignia of the United States Marine Corps. Likewise,

one flagmaker who is Protestant has become well known for producing flags depicting mainstream Christian themes such as the battle between David and Goliath (plate 21).

As the background upon which the central design is to be placed, the field serves to frame the main image or images employed by the flagmaker. For this reason, the shape and decoration of the field are particularly important. The fields of most drapo are rectangular; a simple reflection of the basic square shape of Vodou flags. Occasionally, however, flagmakers create drapo which feature diamond-shaped or circular fields (plates 40, 44, and 45). By introducing these more elaborate designs, the artists increase both the complexity and aesthetic appeal of their works.

On most older Vodou flags, the field is generally ornamented with widely spaced sequins and beads that add color and sparkle to the banner but do not conceal the background fabric (plates 10 and 11). Now that they have greater access to decorative materials, flagmakers usually choose to cover the field completely so that none of the fabric shows through. This way, the entire flag sparkles and shimmers in the light. The fields of most newer flags are monochromatic, having been composed of thousands of sequins of the same or similar color. However, some drapo have much more complex fields featuring geometric patterns consisting of multi-colored diamonds or squares that have been diagonally bisected to form triangles (plate 6).

Minimal or nonexistent in many early drapo Vodou, border patterns have become increasingly prominent and complex in the works of modern flagmakers. Some older flags, such as one dedicated to Ogou/Sen Jak and owned by the oungan Raymond Kasin, have no border other than outlying sections of fabric not covered by the design of the field (plate 6). Other flags are decorated with a wide variety of geometric patterns which enliven the banners and allow the flagmakers to demonstrate their ability to create intricate patterns and designs. Some flagmakers are, in fact, best known for the border patterns which they use on their flags.

The continuance of "traditional" Vodou flagmaking techniques, together with artistic innovation and the rapidly growing emphasis on providing flags for tourists, gallery owners, and museum curators, has resulted in the development of two general types of Vodou flags: those which are made to be used in ceremonies (drapo sèvis) and those which are manufactured primarily for the international art market. Vodou flags created for art collectors rather than for Vodou practitioners are generally referred to by their makers as "art" flags. Although largely based upon drapo sèvis in form and

content, the art flags differ from their predecessors in a number of ways.

The central motifs or images used on art flags are often much more elaborate and imaginative than those found on drapo made specifically for Vodou services. Tourists and art dealers tend to be more interested in the decorative and aesthetic features of flags, and the artists must respond to these factors if they wish to make a name for themselves in the international art market. As a result, emphasis is placed on creating more dynamic central images and colorful borders exhibiting greater geometric complexity. Whereas a drapo sèvis dedicated to Ogou created thirty years ago may have featured a small image of the deity in the center of an expansive field of scattered sequins bounded by a minimal border, an art flag made today would most likely bear a large representation of Ogou which dominates the field and is surrounded by an extravagant border.

As a category, art flags depict a much wider variety of Vodou deities and spirits than do drapo sèvis. The latter usually represent only deities such as Danbala, Ezili Freda, Gede, and Ogou, for whom ceremonial banners are essential. In the international art market, as opposed to the Vodou temple, variety is of greater importance than ritual utility. The more unique and unusual a flag is, the more likely it is to attract buyers. For example, one would not expect to find a drapo sèvis honoring

the spirit Revenan Boumba; however, the artist Yves Telemak has created at least one beautiful art flag depicting that entity (plate 43). Due to the work's originality and distinctive subject matter, it sold quickly.

Since art flags are created primarily as decorative items rather than as liturgical objects, several notable structural differences between drapo sèvis and art flags have developed. Art flags rarely have the decorative fringes that characterize drapo sèvis. An essential component of a "finished" ritual flag, the fringe on a drapo Vodou evokes comparison with that found on fancy military and national flags. These, of course, are the models from which the original drapo Vodou were derived. Art flags are conceptualized more as paintings than as flags and, thus, the fringe has largely disappeared. A second structural distinction between drapo sèvis and art flags is that the latter rarely have the bindings or sleeves that allow the former to be easily attached to staves (plates 7, 8, and 9). This is a simple reflection of the fact that art flags are more likely to be hung on walls than affixed to staves.

As a result of the partial shift from functional art to decorative art, the sizes and shapes of drapo Vodou have become increasingly variable. Whereas the dimensions of traditional flags were relatively standard (forty inches by forty inches), art flags can range from very small (twelve

inches by twelve inches) to quite large (forty inches by eighty inches). This increased flexibility in sizing is an important development for several reasons. Smaller art flags are easier to manufacture and more affordable to tourists than large ones. On the other hand, flags which are larger than the traditional size allow artists to expand upon the number and types of images they use. As a result, some flagmakers have created works that are more akin to tapestries than flags.

As the art of Vodou flagmaking has evolved over the last two decades to include the production of both ceremonial and art flags, two distinctive flag styles have emerged which reflect notions of tradition and of artistic innovation. When creating a flag, either a drapo sèvis or an art flag, a contemporary flagmaker may choose to design one that is conceptualized as either "old style" or "new style."

As the name suggests, "old style" flags are closely patterned after the older drapo sèvis used during Vodou ceremonies. Whether made for the international art market or a Vodou temple, old style flags are seen by their makers as representative of the traditional form of drapo Vodou. The most notable characteristics of these flags are diamond-shaped fields and sequins which appear in a widely spaced pattern rather than as a complete covering of the flag's fabric (plate 44). Among the reasons given by artists as to why they continue to make old style flags is the desire to maintain purity of form and to keep alive the roots of the flagmaking tradition. Economic factors have also fueled the continued production of such flags; those who specialize in bulk production of low-priced flags for the tourist trade prefer to manufacture drapo with simpler designs and fewer sequins (plates 22 and 23).

In practice, the term "new style" may be ascribed to any drapo Vodou which is not "old style." Completely covered with sequins instead of being sparsely decorated and having round, square, or rectangular fields rather than diamond-shaped ones, new style flags represent the cutting edge of the Vodou flagmaker's art. While old style flags may be valued as the most traditional of drapo styles, many of the flags used in urban Vodou temples and the majority of those offered for sale are new style. Because of their lavish decoration, new style flags tend to be more attractive to Vodou practitioners than old style flags. And if they are more attractive to the eyes of practitioners, it can be argued, why would they be any less pleasing to the spirits?

In short, the existence of both "old" and "new" styles of flags allows flagmakers to demonstrate mastery over the root of the art form while also providing opportunity to showcase individual creative talents. Thus an artist can remain relatively faithful to the ritual origins of the tradition within

which he works while also expanding the genre as an art form.

Constructing the Flag

When setting out to make a drapo Vodou, the artist first stretches a single piece of strong fabric, such as burlap, cotton, or a synthetic material, over a square wooden frame. The basic design to be used on the flag is then drawn or stenciled onto the fabric. Once the pattern is set in place, the flagmaker begins the arduous task of attaching sequins, beads, and perhaps a chromolithograph of a Catholic saint to the fabric.

The technique used for the application of beads and sequins is best described as a five-step sewing process (cf. Girouard 1995: 359). First, the flagmaker inserts needle and thread up through the underside of the fabric, through a sequin, and then through a bead that holds the sequin in place. The needle is then sent back through the sequin and the fabric, tightly fastening both the sequin and bead to the flag. These basic movements are repeated over and over until the stencil pattern and background have been transformed into colorful, glittering designs. In some cases as many as twenty thousand beads and sequins may be affixed to the cloth.

Depending on the size of the piece, the intensity of labor, and the availability of fabric, sequins, and beads, the creation of a single Vodou flag can take anywhere from one week to several months. Of course, a flag paid for up front always gets finished faster than one ordered cash upon delivery. Most prominent flagmakers maintain workshops (atilye) staffed by several skilled assistants who do the bulk of the work attaching sequins and beads to the flags. The central images are normally designed by the head of the shop, but exceptional assistants may occasionally create some of the images used on the flags under the guidance of the master artist. This enables the flagmaker to have several flags in production at the same time.

Some of Haiti's most famous flagmakers no longer participate in the sewing process at all but concentrate solely on the creation of new designs and patterns. They suggest that the most important issue to be addressed in making Vodou flags is the artistic vision that motivated the creation of the objects. Above all else, drapo are works of devotion that are inspired by the artists' conceptions of the lwa. Anyone can learn to sew, but there are few individuals who possess the ritual knowledge and wealth of creative ideas that enable them to provide food, pay, and ample work for a crew of assistants.

The ability to demonstrate advanced technical skill is, nonetheless, essential for top flagmakers, who take pride in their own adroitness with needle and thread, as well as carefully monitoring the level of

competence displayed by the workers apprenticed in their atilye. Apprenticeship to an established flagmaker is the primary means by which the tradition is passed on to new generations of artists, and it is taken very seriously. Most contemporary flagmakers started their careers sewing in the atilye of an older artist, and only after they had mastered the techniques of flagmaking did they begin to work under their own names and open their own workshops.

Once proficient in the basic skills, flagmakers begin to display their mastery of the art in tightness of sequin arrangement, evenness of patterned lines, innovative use of color, tint, and hue, and clarity of the image portrayed on the flag. Artistic innovation and the influence of personal aesthetics have made works by most premier flagmakers readily identifiable and easily distinguishable from one another. Drapo created by Antoine Oleyant, for example, are characterized by a subtle blending of colors and flowing designs which impart a sense of dynamic movement rarely seen in flags created by other artists (plate 24).

Even though Vodou drapo, as a contemporary art form, are no longer strictly associated with the practice of Vodou, the majority of Haiti's foremost flagmakers are initiates. Almost all are men, many of whom are well-known oungans whose temples serve both as places of worship and as workshops for creating flags. While many of the assistants who sew in the atilye of premier flagmakers are female, there are practically no women who have gained recognition as artists in their own right. All of the leading flagmakers profiled by Tina Girouard in her ground-breaking book *Sequin Artists of Haiti* are men. Why this is the case is not entirely clear, but it most likely reflects the fact that Haitian society is, in general, male dominated, with men tending to achieve the highest ecclesiastical ranks in Vodou and often having better opportunities to accumulate the money and resources required to establish an atilye.

Blending time-honored ritual designs and images with innovative styles and unique artistic visions, contemporary Vodou flagmakers have taken the genre into new realms of artistry. Marked by increasingly complex backgrounds and borders composed of shifting colors and geometric patterns, contemporary banners clearly demonstrate that the beauty of Vodou flags transcends their ritual context. Shaped by the work of emerging artists, a popular Haitian art form has emerged which depicts and comments on the social and political realities of Haiti as well as on the nature of the Vodou lwa.

Vodou flagmakers now create works of art with two specific sets of patrons in mind. One group is composed of Haitian Vodou initiates who require drapo sèvis for use in ceremonies. The other represents individuals, mostly foreigners, who collect drapo as works of art, largely ignoring their ritual implications. Although flagmakers are highly conscious of the fact that their art form is firmly rooted in the providing of ritual flags to Vodou congregations, few are willing or can afford to ignore the opportunities for artistic innovation and financial gain presented by involvement in the international art market.

Silva Joseph and Yves Telemak are two of the most prominent Haitian artists who currently make flags for Vodou societies and art collectors. Representing two generations of flagmakers, their works reflect, to varying degrees, both an adherence to traditional techniques and aesthetics and a willingness to explore new directions in their art.

Silva Joseph

Born in 1930 in Leogane, Haiti, Silva Joseph is an oungan and flagmaker who currently resides in the Bel-Air district of Port-au-Prince (plate 25). Working out of several small rooms in his ounfò, Silva and his assistants create the superb Vodou flags which have made him one of the most renowned members of the "Bel-Air school" of flagmakers. He is also a notable example of a prominent artist who no longer participates in the sewing of the flags produced in his workshop. Silva prefers to concentrate on creating the designs, selecting colors, and drawing the pattern onto the fabric; he lets his sewers do the sequin work. "All that sewing," he states with a slight smile, "is a job for younger hands anyway." His role now is that of artistic director supervising a cooperative project. Silva rarely puts his name or initials on flags produced in his atilye, but will do so when asked by collectors.

When I first entered Silva's ounfò in Bel-Air, I was led into the peristil and asked to sit down on a folding chair near the temple's poto mitan. Upon learning that I was interested in purchasing drapo Vodou, Silva excused himself and went to a small

room near the front of the ounfò. He soon returned, followed by several members of his atilye who brought out nine beautifully sequined banners. Although still attached to the wooden frames on which they had been sewn, all were ready for sale. The sequin work had been finished and all that remained to be done was to remove the works from the frames and attach a colorful backing.

Silva's preference for traditional Vodou imagery and his emphasis on symmetry and crisp detail have made the flags from his workshop popular with Vodou practitioners and art collectors alike. His signature designs are normally composed of large central motifs based on vèvè or Catholic chromolithographs set within monochromatic fields. His typical border style features rows of opposing semicircles which form hourglass or diamond-shaped areas between them (plates 26–30). Some of Silva's more recent flags display borders composed of small squares of various colors or small squares and long rectangles arranged in checkerboard patterns (plates 32 and 33). When asked about the development of this alternative border style, Silva replied, "An artist must keep changing." While most of his flags still have the semicircle borders, he now mixes in a few with the square and rectangular patterns as a change of pace.

The majority of the flags made in Silva Joseph's atilye have central motifs closely patterned after the standard vèvè for the lwa to whom the each drapo is dedicated. Since Silva is an experienced priest who regularly traces vèvè on the floor of his temple as part of his ceremonial preparations, the designs are particularly meaningful to him and are easily rendered by his practiced hand. Although most, if not all, of Silva's flags are best categorized as new style flags—fully sequined with rectangular fields and well-defined geometric borders—his flags featuring vèvè seem strikingly traditional. While other artists may use vèvè as a starting point in the creation of central motifs for their art flags, Silva seems content with perfecting the presentation of vèvè through the medium of drapo.

Dominated by its large tripartite central image, Silva's flag for the Marasa (plate 26) amply illustrates the visual effectiveness of combining a simple yet resplendent vèvè pattern with a dynamic border based upon offset semicircles. The intricate border adds color and geometric complexity to the work, but there is no mistaking the fact that the essence of the flag, its selling point, is the clarity and crispness of the vèvè. It is as if one could pick up and carry away the very design that Silva traces out on the ground when he prepares to invoke the Marasa.

Like the flag for the Marasa, Silva's flag for Bawon Samdi (plate 27) is based upon a vèvè featuring the cemetery cross that is

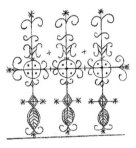

Vèvè for the Marasa.

typically used to represent Bawon and the other members of the Gede family. The large crucifix flanked by skulls is especially evocative of Bawon. To this basic vèvè-inspired design, Silva has added several symbolic icons which illuminate the Bawon's role as lord of the dead. On either side of the cross, near its base, appear a club and a spade, the black suits from a deck of playing cards (ominous suits, perhaps foretelling death). At the apex of the cross, Silva has placed a severed leg and a disembodied hand. Is not Bawon's realm the place where corpses lose their composition? On the flag as in the grave, human bodies decompose.

In his drapo for Mazaka (plate 28), Bawon's close relation, Silva goes a step further in his use of vèvè as a central motif. In addition to employing the cemetery cross, Silva has added a portrait of Mazaka himself. Leaning on a cane and sporting his favorite clothing—wide-brimmed black hat, purple shirt, white jacket, and black pants—Mazaka carefully eyes the grave and the offerings placed on it. This scene is a particularly appropriate one, as it is Mazaka who is charged with the care and maintenance of the graves located in the cemeteries over which the Gedes preside.

Among the finished works displayed in Silva's workshop when I first visited him was a brightly colored flag dedicated to Ezili Freda (plate 29). Dominated by a large red heart with green serpents on either side, the piece closely resembles the vèvè for Ezili Freda. In this flag, as with many others for Ezili Freda, the close relationship between this deity and Danbala is made clear. Cool, soothing, and nurturing, these two complement one another. To the left of the central motif is the outline of a cup which represents the vessel used to pour libations in Ezili Freda's honor. When Vodou ceremonies commence, libations of water, rum, or scented fragrance are splashed in the corners of the temple or at the center pole in order to invoke the gods. To the right of the heart is a candle symbolizing the ones which are lighted during prayer as well as other rituals with which Ezili Freda is associated. The gold background brings to mind the precious jewelry of which she is inordinately fond. The large letter M embroidered across the heart with silver sequins refers to the title by which she is commonly addressed: Metrès (Mistress) Ezili or Ezili Metrès. She is the ideal lover, the epitome of sex and desire, the woman every man should want to have, hold, and serve. She is the mistress who is master.

An important feature of this flag is that it was made with sequins that are significantly larger than those commonly used to create drapo Vodou. These large sequins are referred to by flagmakers and collectors as "embargo sequins," because they became prevalent during the U.S. embargo of Haiti following the overthrow of the for-

mer Haitian president Jean-Bertrand Aristide in October 1991. Sequins, like most other commodities, were scarce and this called for economizing on the part of flagmakers. The use of larger sequins meant that fewer ornaments were needed to completely cover the surface of a flag. Flagmakers seem to greatly prefer the aesthetic qualities of small sequins, and the large reflective sequins used on this flag give it a mirror-like quality rarely seen in drapo Vodou.

Silva is also a master at using drapo for portraiture. The flags produced in his workshop that have central motifs based upon Catholic chromolithographs are unparalleled in their exactness and elegance. A noteworthy example is a drapo featuring St. Peter (Sen Piye), the Catholic apostle who is closely associated with the Vodou lwa Legba (plates 30 and 31). The large central motif is a relatively faithful reproduction in sequins and beads of a chromolithograph of St. Peter. Red and blue sequins re-create the background of the chromolithograph. Sen Piye himself is rendered in sparkling red, blue, gold, and white sequins. The red cock that crowed upon Sen Piye's third denial of Christ and which is the favorite sacrificial animal of Legba is similarly enlivened. This radiant portrait is enclosed by Silva's trademark border done in blue and white. It is important to note that, in this case, Silva took the original image found on the chromo-

lithograph for what it was, a beautiful portrait of a holy man holding the Bible and the keys to heaven, and saw little need to alter or expand upon the design.

Because Silva is an active Vodou priest who maintains an ounfò and presides over a fairly large congregation, he always has a pair of flags on hand that function as his drapo sèvis. The ones he was using in September 1994 were for Ogou/Sen Jak and Danbala in his incarnation as Moses (plates 8 and 9). Silva stated that these were the only two flags he needed for ceremonies and even intimated that because Ogou was the special patron of his ounfò, he could actually get by with just the flag dedicated to Ogou/Sen Jak. Of course, since Silva is an expert flagmaker, it is hard to imagine him ever having just one drapo sèvis for use in ceremonies.

Silva's drapo sèvis remain close to the classical style of ceremonial flags in that three sides are edged with fringe, while the fourth has bindings which allow the flags to be easily attached to staves. At the time of my visit, the flags were, in fact, bound to wooden staves and stored in a small altar room. Although these were his primary drapo sèvis, Silva later sold them to the UCLA Fowler Museum of Cultural History for inclusion in a major exhibition on the sacred arts of Haitian Vodou. As mentioned earlier, it is not uncommon for Vodou practitioners, flagmakers in particular, to sell their drapo sèvis when the op-

portunity arises. Money is usually tight, and they can always make new flags to replace the old ones.

The drapo sèvis for Danbala is typical of those made in Silva's atilye. The central motif is composed of a chromolithograph of Moses which has been entirely sequined over except for Moses's face, showing through a circular piece of clear plastic. The rectangular powder-blue field behind the central image is accentuated with pink semicircles. While the color symbolism may not hold true for the essential imagery of Vodou, it is intriguing to note that this flag for the father figure among the lwa prominently features the colors Americans tend to associate with newborn babies. The central motif and field are surrounded by the familiar border composed of opposing navy blue and gold half-circles set on a red background. The result is an undulating design which moves the viewer's focus towards the image of Danbala/Moses.

In contrast to the flag for Danbala, that of St. Jacques (Sen Jak) is somewhat atypical. The central motif, based on the chromolithograph for St. James Major, is familiar and much like others produced in Silva's atilye. However, the flag's lattice-work border, composed of red and white diamonds, is quite unusual for a work by Silva Joseph and evokes comparison with one of the more popular vèvè for Ogou Badagri. Recognizing that diamond-shaped

patterns were perhaps a more appropriate background for Ogou, Silva eschewed his customary half-circle border style. Also unusual are the S-shaped emblems which surround the central image. These are much like the S-shapes which frequently turn up in vèvè or are attached to the ends of flagstaves. They clearly lend a sense of dynamic energy to the flag.

Spirits associated with water, both fresh and salt, are among the most commonly invoked deities in the Vodou pantheon. Because they belong to an island culture with a predominantly agrarian economy, many Haitians must depend upon the seasonal rains and the often uncertain replenishment of local water sources for the survival of their crops and livestock. Water is life. Likewise, open and safe access to the sea-lanes and fishing grounds of the Caribbean is essential. The availability of fish and of imported goods is a fundamental concern. Not surprisingly, numerous rituals and feasts are held in honor of the water spirits. It is they, above all, who have the power to bring down the rains from the heavens and to offer up the riches of the ocean.

Because of their status as the paramount water spirits within the religion, Agwe and Lasirèn are frequently depicted on drapo Vodou. Like most prominent flag-makers, Silva Joseph has created many flags for Agwe and Lasirèn since he opened his

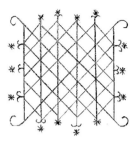

Vèvè for Ogou Badagri.

workshop. In fact, when I first visited him, he and his assistants had just finished a pair of flags dedicated to the king and queen of the ocean. Highlighted with aqua-blue and sea-green sequins, these beautiful flags evoke both the crystal waters of rivers and springs and the azure depths of the ocean.

In designing the central motif used on his flag for Agwe (plate 32), Silva employed the most common vèvè pattern associated with the deity, the traced outline of a ship. Since Agwe is the lord of the ocean, what could be a more fitting symbol for the god and his relationship with humans than the vessels which carry sailors, traders, and refugees across the wide expanses of his watery domain? Set against a solid background composed of gold sequins, Agwe's ship closely resembles the small boats, rigged with sails and diesel engines, used by inter-island traders throughout the Caribbean. While flags for Agwe made by other artists often sport warships, steamboats, or fanciful yachts as their central motifs, Silva's design seems closer to the type of ship that actually has the greatest impact on daily life in Haiti, the merchant ship that brings the food and supplies necessary for survival.

Like the flag for Agwe, the drapo for Lasirèn (plate 33) utilizes the most popular, if not the only, representation of the goddess, that of the mermaid. Depicted as half woman and half fish, she is the legendary siren who beckoned Ulysses on the wine-dark seas of the Mediterranean, who tempted homesick seafarers during the long voyages to the Americas, and who today sings sweetly to faithful worshippers congregated in Vodou temples. In her hand she holds the trumpet with which she creates her enchanting music. Floating around her in the central field are other icons closely associated with her. To her left is her golden comb. Known for her vanity, she spends hours preening and primping her hair. Those who claim to have encountered her on the shores of the ocean or at the mouth of a river on moonlit nights often say they surprised her while she was combing her hair. To Lasirèn's right is a fish symbolizing her aquatic home. There is also a star signifying her divinity; since Vodou deities are often compared to the shining celestial bodies that populate the heavens, stars are a common artistic motif.

Yves Telemak

Although still in his thirties, a relatively young age for an established artist, Yves Telemak has become a prominent member of the famous "Bel-Air school" of flagmakers (plate 34). The son of a respected Vodou priest, Yves began his career by working as an assistant in the atilye of the Bel-Air flagmaker Joseph "Boss To" Fortine. After learning the craft from "Boss

To," Yves ventured out on his own. Eager to design drapo Vodou that expressed his personal artistic vision, Yves transformed a room in his family compound into a small workshop and began making flags.

Like most premiere flagmakers, Yves makes drapo for Vodou societies, but the vast majority of his flags are sold to tourists and art collectors. The central motifs of his works are inspired by the religious traditions of his family, suggested by friends and acquaintances, or based on popular images culled from magazines and tourist brochures. Brilliantly expanding upon the distinctive styles employed by the Bel-Air artists with whom he trained, Yves's complex geometric patterns and wide polychromatic borders make his work the most readily identifiable of any contemporary flagmaker. Concerning his trademark borders, Yves states that he doesn't want his works to look like those produced by other artists but to reflect his own individual style. When people see a flag with such borders, they will say, "Ah, Yves Telemak."

Even though he wants his flags to be readily distinguishable from those of other flagmakers, Yves, like Silva Joseph, is reluctant to put his name on the flags. This is due, at least in part, to the artist's discomfort with individualizing and commercializing a communal sacred art. Even though he is creating unique works largely intended for use outside of the context of Vodou,

Yves is uneasy about the idea of putting his name on an object dedicated to a deity. Nonetheless, he does affix the signage "Art Y. T." or "Y. T. Art" to most of his flags. The addition of the word "Art" to Yves's initials is significant. It strongly suggests that he wants the piece to be thought of as commercial art rather than as a liturgical object.

When asked why he signs his flags if he would prefer not to, Yves responds that his father told him he should always put his name on his flags. Personal and philosophical reservations aside, the economic context of contemporary flagmaking makes this an inherently reasonable thing to do. It's a simple fact that flags which have the maker's name on them are more valuable on the art market. Furthermore, when a flagmaker signs his creations, it's harder for someone else to take credit for the work. Of this unfortunate reality, Yves says, "One time a man bought one of my flags, took it home, and sewed his own name on to it." After finding out about the episode, Yves's father reiterated: "Sign your flags."

Realizing the importance of signing his works but still preferring not to, Yves came up with a compromise solution. He affixes his signage "Art Y. T." to the new style art flags he makes, but does not put his name on old style flags or works whose central motif was designed by someone else (plate 44). By not signing old style flags, which resemble the traditional drapo

Vodou used in ceremonies, Yves reaffirms the notion that they are sacred to a deity and a community of worshippers. As such, they should not be signed by the maker. With regard to refraining from signing art flags based upon someone else's idea, Yves says, "A friend might come with a design or picture. I say 'That's good imagination.' So I do the sequin work. But I don't sign it." Thus, Yves differentiates between the art flags which evolve out of his own artistic vision and those which emulate traditional drapo sèvis or which were imagined by someone else.

Two flags, one dedicated to the cool, soothing goddess Ezili Freda and the other to her hot, fiery counterpart Ezili Dantò, provide good illustrations of how Yves blends traditional and innovative styles and motifs in his art flags.

In making the flag for Ezili Freda (plate 35), Yves chose to use a chromo-lithograph depicting Mater Dolorosa, Ezili Freda's Catholic incarnation, as the central motif. Once the outlines of the flag's field and borders were drawn, the paper chro-molithograph was sewn onto the center of the field (plates 36 and 37). Yves then cov-ered the chromolithograph with sequins, beads, and clear plastic. He did not attempt to reproduce every nuance of the underly-ing chromolithograph with the colorful or-naments. Instead, he re-created only the silhouette of the Virgin herself and several of the ornate hearts which surround her.

Her clothing is rendered in blue, red, and white sequins. Gold sequins enliven her crown and the large jeweled hearts. Clear plastic covers her face and hands so that the flesh tones of the underlying chro-molithograph show through. Everything else in the chromolithograph is buried under the expanse of red sequins which forms the background. Above the Virgin's now radiantly sequined halo, the name Erzulie Freda is spelled out in faux-pearl beads. At the bottom of the field, to the right and left of the image, the word "ART" and the initials "Y. T." are formed in the same beads.

Following the completion of the field and central motif came the decoration of the intensely geometric border design, Yves's trademark. Using a wide palette of color, he filled in the array of squares, rectangles, triangles, and L-shaped figures which formed the flag's border. After fin-ishing the border, he removed the now-completed flag from its wooden frame and attached a blue cotton backing. The entire process took approximately one week.

Yves followed the same basic procedure in making the flag dedicated to Ezili Dantò (plate 38), but there is a significant differ-ence in how he designed the flag's central motif. As with the flag for Ezili Freda, the image of Ezili Dantò is patterned after a Catholic chromolithograph. In this case the image is copied from one depicting the Virgin Mary as Mater Salvatoris, the black

33

Madonna (plate 39). However, instead of attaching the image itself to the flag, Yves traced a small outline of the Virgin and Holy Child copied from the chromolithograph directly onto the fabric with an ink pen. This rendering was then filled in and finished with sequins of the appropriate colors.

Rather than relying solely on the use of the image of Mater Salvatoris to portray Ezili Dantò, Yves also includes in the central motif objects which are sacred to Ezili Dantò or are symbolic of her nature. Surrounding the image of Ezili Dantò/Mater Salvatoris are a cooking pot, a cup, a red-and-gold heart, a sword, a rattle, a candle, and a large black pig. Concerning these elements, Yves stated, "My father taught me about Ezili Dantò and the things that are associated with her." According to Yves, the pot is for cooking offerings, the cup is for libations, the heart signifies Ezili Dantò's strong maternal instincts, the rattle (or cha-cha) is used to call Petwo deities like herself, the sword symbolizes the weapon which left two scars on her cheeks, and the candle represents the ones commonly used in ceremonies. The presence of the large black pig is particularly meaningful. It is the favorite animal of Ezili Dantò and the one she prefers to receive as a sacrifice. For this reason, Yves made the pig as prominent as the image of Mater Salvatoris. He says, "Everybody makes flags with big pictures of Ezili Dantò. I wanted to do some-

thing different. So I emphasized the pig. It's what people should sacrifice, it's what she wants. When Dantò comes, the pig is presented to her."

Although many flagmakers have created drapo depicting the mermaid goddess Lasirèn, it is Yves Telemak's name which has become most closely associated with the creation of exquisite art flags bearing her likeness. When making a flag for Lasirèn, Yves utilizes a basic pattern which he traces out each time. His stock image of Lasirèn is much like that used by other artists; however, Yves adds personal touches which make his renderings of Lasirèn much more captivating than those of his colleagues. Yves's continually evolving interpretation of Lasirèn and the fantastic geometric borders and innovative use of color for which he is renowned make his flags for the goddess distinct and highly sought after by art collectors.

A comparison of three drapo for Lasirèn made by Yves over the course of approximately four years demonstrates both continuity and variation in his art. The flags are strikingly similar in some ways, quite different in others. For Yves, each new flag presents an opportunity to explore fresh ways of depicting Lasirèn; thus, no two flags are alike. To be a work of art, each flag must be unique.

The first of the three Telemak Lasirèn flags was produced during or shortly before 1990 (plate 40). Flanked by two gold-

and-salmon-colored fish, this silver-skinned mermaid with a kaleidoscopic tail firmly clutches her beloved trumpet. Yves's use of scattered sequins in decorating the field and the fact that he did not sign the flag strongly suggest that it was created as an old style flag. However, the circular border does not follow the pattern of other old style flags by Telemak which have diamond-shaped borders (plates 44 and 45). This flag, by all appearances, reflects Yves' desire to explore the aesthetic and categorical boundaries of the art form. It doesn't conform to the basic conventions of Yves's old style flags, but neither does it match his new style flags. The drapo seems to fall somewhere in between the two styles, perhaps an early incarnation of a form that is just beginning to emerge.

The second drapo for Lasirèn (plate 41) was produced in 1992, and when compared to the earlier flag, evinces some significant differences. Although still envisioned as a half-woman, half-fish siren holding a trumpet, she is now black rather than light-skinned and has flowing black tresses on one side of her head and short golden blond hair on the other. No longer accompanied by fish, she is instead surrounded by prized possessions and liturgical items: rattle (*ason*), bell, candle, comb, cup, and mirror. Completely covered with sequins and beads and signed with the initials "Y. T.," the banner is clearly a new style art flag. Whereas the border of the previous flag. Whereas the border of the previous

drapo was relatively minimal, this one bears a wide rectangular border composed of a variety of triangles and half-circles.

The third flag for Lasirèn, now called Mambo Lasirèn (plate 42), was made in 1993 and arguably represents the integration of the border theme of the first flag with the new style fully sequined construction and imaginative reinterpretation of Lasirèn seen in the second. Although the compass points are new, the flag's circular border is reminiscent of that displayed on the earliest of the three flags. However, Yves used triangles instead of multicolored rectangles to create the border's interior geometry. While the shape of the mermaid is exceedingly similar to that of the first, she is now brown-skinned instead of silver, and the hair is black and gold as in the second of the three flags. Furthermore, the addition of a heart-shaped necklace and the use of strikingly different colors for her torso and tail make the work unique. Fully sequined and showing the signage "Y. T. ART," this, too, is clearly a new style art flag.

Of the image of Lasirèn presented in the latter two flags, Yves states that the inspiration to make half of her hair gold came from a magazine advertisement that featured a flaxen-haired mermaid. In an interview with art historian Marilyn Houlberg, Yves offered several reasons for his fascination with this adjustment to Lasirèn's image. First of all, according to Yves, the

blond hair shows where the sun is shining on Lasirèn. Second, he made the larger portion of her hair black because, although Lasirèn is usually conceptualized as light-skinned, she is Haitian and thus more black than white. The inherent duality of Lasirèn, as shown in the evolution of Yves's mermaid flags, is brilliantly summed up by Houlberg: "She is part black, part white; part Haitian, part European; part Rada, part Petwo. And, of course, she is also part human and part fish" (1996: 33). She is an ambiguous ever-changing goddess, and Yves's various attempts to depict her certainly reflect that aspect of her nature.

Yves is also noted for his fascination with the mischievous and/or malicious beings who are occasionally listed among the hot, hard spirits. He often utilizes these beings as subject matter for new style art flags. Generally believed to be closely associated with malign sorcery and regarded as demons or devils (djab), spirits such as Revenan Boumba (plate 43) are invoked by only the most confident or foolhardy individuals. It is said that those desirous of wealth or material goods can strike bargains with Boumba and his cohort of djabs, but the price of so doing is thought to be exorbitant. The streets of Port-au-Prince are rife with legends about greedy men who sought to gain riches with the purchased aid of a djab, but who succumbed to their own greed when they could not meet the payments and had to pay with a pound of flesh. The prominence of the knife and whip in the central field suggests this aspect of Revenan Boumba's nature. The strange combined hand and foot refers to the belief that djab are often distinguished by mutations involving hands and feet. Some may have six feet; others have hands sprouting from their heads.

Although celebrated for his new style art flags, Yves also takes great pride in the old style flags which he makes (plate 44). Compared to the excitement generated by his new style flags, Yves's old style flags receive relatively little acclamation from art collectors. This may be due in large part to the fact that he does not sign the works, so that old style art flags made by him may pass from dealers to collectors without the final owners realizing whose work they possess. Because Yves Telemak flags have been stereotyped as being fully sequined pieces with extravagant borders, some buyers would simply not ascribe old style flags to him. One authority on drapo Vodou has testified that Yves's works are always completely covered in sequins, but this is simply not the case.

Two flags by Telemak depicting members of the Gede family demonstrate his dedication to creating both old style and new style flags and illustrate the similarities and differences between the two forms.

The first, an exquisite purple-and-white drapo bearing the name Societe Lacroix (Sosyete Lakwa) exhibits the classic dia-

mond-shaped field decorated with widely spaced sequins (plate 44). As one would expect of an old style flag produced by Yves, the piece does not carry the maker's initials. The banner's central image is based upon the traditional vèvè for the Gedes— the cemetery cross on which a skull and crossbones is superimposed. Telemak's version, however, is particularly ornate and closely resembles the fancy decorative wrought-iron crosses that are often placed atop Haitian graves. Surrounding the cross are a cup for libations, a candle, and the pick and shovel used to dig and seal the graves through which those leaving the world of the living enter into the realm of the dead.

The second of the two flags (plate 46), a new style art flag dedicated to Ti Pice Lacroix (Ti Pis Lakwa), is similar to the old style flag for Sosyete Lakwa in that Yves uses an almost identical cemetery cross as part of the central image. However, because it is a new style flag, he expanded on the design, adding the figure of Ti Pis himself. The image used is remarkably like that employed by Silva Joseph on his flag dedicated to Mazaka (plate 28). Given the proximity of the two men's workshops and the fact that they move within a small circle of Bel-Air flagmakers and Vodou priests, similarities in the flagmakers' depictions of the deities are unavoidable. Although neither artist would admit it when asked, it is highly likely that they have occa-sionally shared some of the homemade cutout patterns often used to trace designs onto a flag's fabric.

The sparkling banners made by Silva Joseph, Yves Telemak, and their contemporaries suggest that the creation of drapo Vodou is best understood as a process of artistic and spiritual revelation. Inspired by myths, legends, and unique personal visions, Vodou flagmakers weave together time-honored sacred designs and newly appropriated images to create works that are both ancient and modern and are always captivating. As creators of ritual objects, flagmakers seek to recognize and reveal the inhabitants of the spirit world. In so doing, they utilize a variety of images to represent the lwa because they *know* that the gods of Vodou exist in multiple places and forms—Africa and the Caribbean, African gods and Catholic saints, the living and the dead. The flags are, above all else, visual testimonials to the fact that the lwa are now and always will be present and active in the lives of Vodou practitioners.

As works of art informed by ritual and theology, as well as by Haiti's political history, drapo offer a rare opportunity for viewers to experience, albeit indirectly, the aesthetics, symbolism, and social implications of Vodou. By illustrating the essence of Vodou as interpreted by practitioners, the flags challenge us to rethink outsider conceptions of Haitian popular religion. A

37

foreigner seeing drapo Vodou for the first time may be surprised to learn of their origin, and think, "These are beautiful. Are they really associated with voodoo?" The spiritual realm reflected in the flags is not the dark, frightening place of black magic and superstition that stereotypes about Vodou and Haiti lead many to expect. Instead, drapo exemplify the beauty, elegance, and enduring embrace of gods and ancestors in all their manifestations.

Asafo: Local military organizations created by the Fante/Asante people of Ghana. Noted for their use of colorful flags.

Atilye: Workshop; used to refer to a flag-maker's studio and to those who work for him.

Ason: Sacred rattle used to invoke the Vodou deities.

Balanse: To balance, create equilibrium among spiritual forces. Often demonstrated by pairing flags dedicated to "hot" spirits with those honoring "cool" ones.

Banda: A sexually suggestive dance that is the favorite of Bawon Samdi.

Chromolithograph: A brightly colored paper image of a Catholic saint.

Djab: Demon, devilish spirit.

Drapo: Flag; **drapo sèvis**: flag used in Vodou ceremonies (services), as opposed to flags which are created for the international art market and not used in rituals.

Escola de samba: A group or "school" of masqueraders who parade together during Carnaval in Brazil.

Ginen: Generic term used in Vodou to refer to Africa.

Kò-drapo: Flag corps, color-guard; they parade Vodou societies' flags during ceremonies.

Laplas: Swordmaster; he leads the kò-drapo during the presentation of the flags.

Lwa: Spirit, deity.

Manbo: Priestess.

Nanchon: Nation; usually refers to a grouping of Vodou spirits based on ethnic affiliations such as Kongo, Ibo or Rada.

Ounfò: Temple.

Oungan: Priest.

Ounsi: Initiate, member of a Vodou congregation.

Peristil: Main ceremonial chamber in a Vodou temple.

Petwo: Pantheon of "hot" Vodou spirits noted for their harsh and abrasive personalities and often malevolent behavior.

Poto mitan: Center pole of the peristyle, near which most Vodou rituals occur.

Rada: Pantheon of "cool" Vodou spirits generally associated with healing and spiritual protection.

Sèvis: Vodou ceremony or service; **sèvis drapo de**: ceremony in which two flags are used; **sèvis drapo twa**: ceremony in which three flags are used.

Sèvitè: Servitor; a Vodou practitioner.

Sosyete: Society; a Vodou congregation.

Vèvè: Spirit-invoking ritual designs often used as central motifs on Vodou flags.

Bastide, Roger. 1971. *African Civilizations in the New World*. New York: Harper & Row.

Brown, Karen McCarthy. 1991. *Mama Lola: A Vodou Priestess in Brooklyn*. Berkeley: University of California Press.

Cosentino, Donald J., ed. 1995. *Sacred Arts of Haitian Vodou*. Los Angeles: Fowler Museum of Cultural History.

Courlander, Harold. 1973. *Haiti Singing*. New York: Cooper Square Publishers, Inc.

Dalzel, Archibald. 1967 [1793]. *History of Dahomey*. London: T. Spilsbury and Son.

Deren, Maya. 1983. *Divine Horsemen*. New York: Documentext.

Drewal, Henry. 1996. "Mami Wata Shrines: Exotica and the Construction of the Self." In *African Material Culture*, ed. Arnoldi, Geary, and Hardin, 309–33. Bloomington: Indiana University Press.

Flores-Peña, Ysamur, and Roberta Evanchuk. 1994. *Santería Garments and Altars: Speaking Without a Voice*. Jackson: University Press of Mississippi.

Girouard, Tina. 1994. *Sequin Artists of Haiti*. New Orleans: Contemporary Arts Center of New Orleans.

————. 1995. "The Sequin Arts of Vodou." In *Sacred Arts of Haitian Vodou*, ed. Donald J. Cosentino, 357–77. Los Angeles: Fowler Museum of Cultural History.

Houlberg, Marilyn. 1996. "Sirens and Snakes: Water Spirits in the Arts of Haitian Vodou." *African Arts* 29, no. 2 (spring): 30–35.

Maximilien, Louis. 1985. *Le Vodou Haitien*. Port-au-Prince: Imprimerie Henri Deschamps.

Metraux, Alfred. [1959] 1971. *Voodoo in Haiti*. New York: Schocken Books.

Polk, Patrick. 1995. "Sacred Banners and the Divine Cavalry Charge." In *Sacred Arts of Haitian Vodou*, ed. Donald J. Cosentino, 325–47. Los Angeles: Fowler Museum of Cultural History.

Reis, Joao Jose. 1993. *Slave Rebellion in Brazil*. Baltimore and London: The Johns Hopkins University Press.

Rigaud, Milo. 1985. *Secrets of Voodoo*. San Francisco: City Lights Books.

Thompson, Robert Farris. 1984. *The Flash of the Spirit*. New York: Vintage Books.

Thornton, John. 1992. *Africa and Africans in the Making of the Atlantic World, 1400-1680*. Cambridge: Cambridge University Press.

Yonker, Dolores. 1991. *Sequined Surfaces: Vodoun Flags from Haiti*. Exhibition catalogue. Northridge: Art Galleries of California State University.

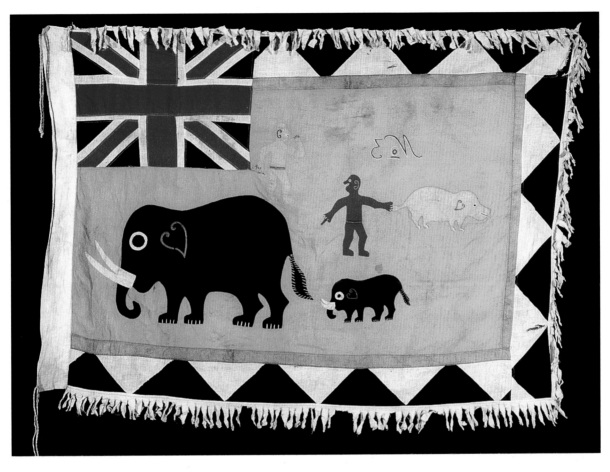

P L A T E I
Asafo military flag used by
Fante people of Ghana.
UCLA Fowler Museum of
Cultural History
X90.24.150.

41

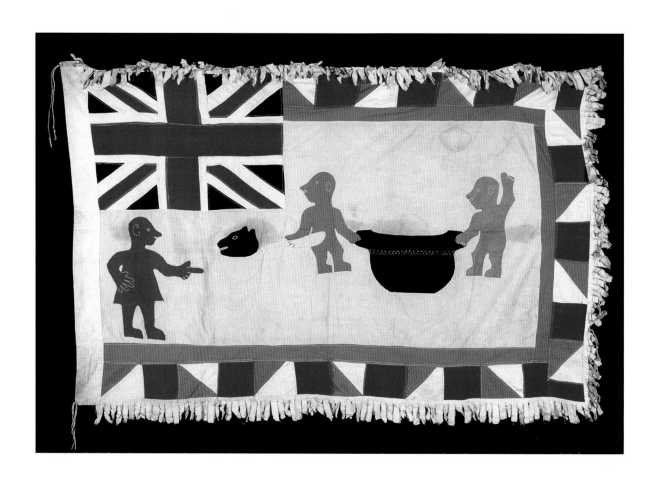

PLATE 2
Asafo flag. FMCH
X90.24.155.

42

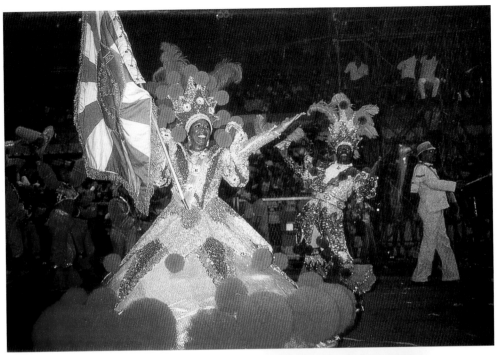

Above:
P L A T E 3
Every samba school (*escola de samba*) in Brazilian Carnival is preceded by its flag bearer (*porta bandeira*).

Left:
P L A T E 4
Red cotton flag dedicated to the African god (orisha) Shango in Grenada.

43

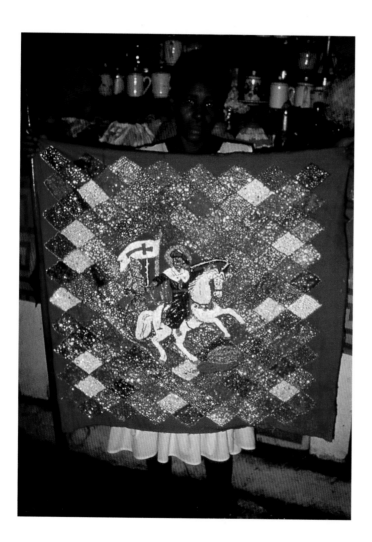

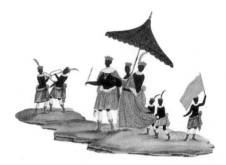

Above:

P L A T E 5

This early-nineteenth-century Brazilian water-color depicts the honorary "kings" and "queens" who were elected by members of the slave community.

Left:

P L A T E 6

Drapo sèvis for Ogou in his incarnation as Sen Jak (St. James Major). Temple (ounfò) of Raymond Kasin, Port-au-Prince.

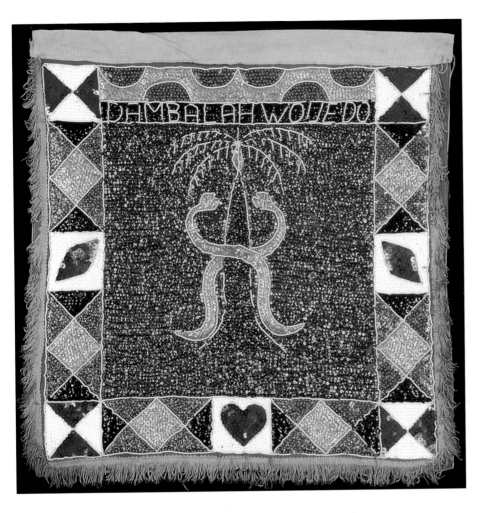

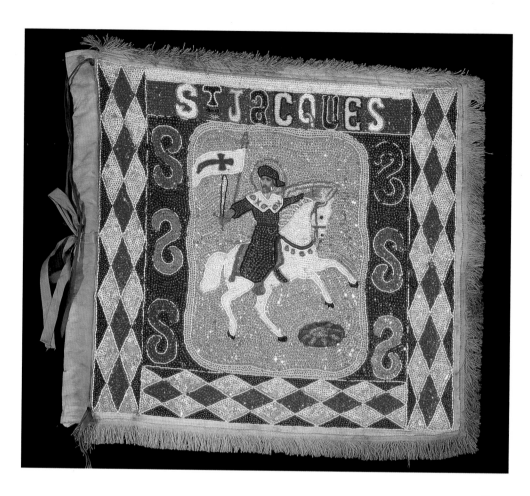

PLATE 8
Drapo sèvis for Ogou/Sen
Jak. Workshop of Silva
Joseph. FMCH
X94.50.1B.

46

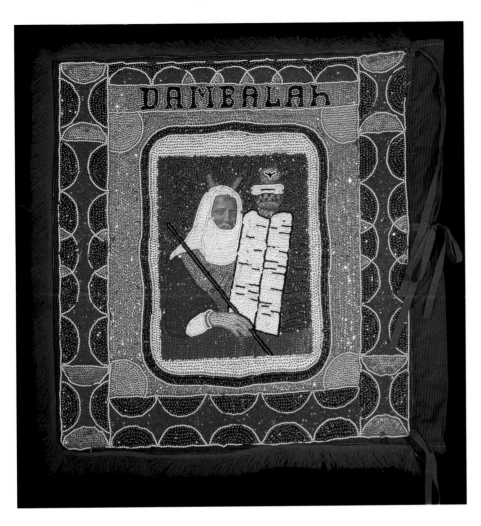

PLATE 9
Drapo sèvis for Danbala.
Workshop of Silva Joseph
FMCH X94.50.1A.

47

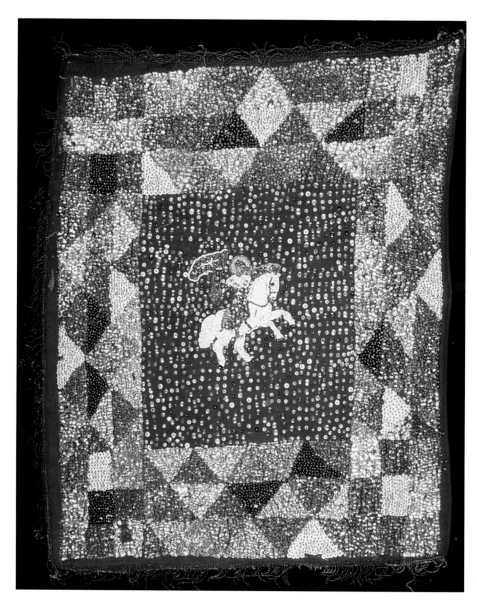

PLATE 10
Drapo sèvis for
Ogou/Sen Jak. FMCH
X94.2.9A.

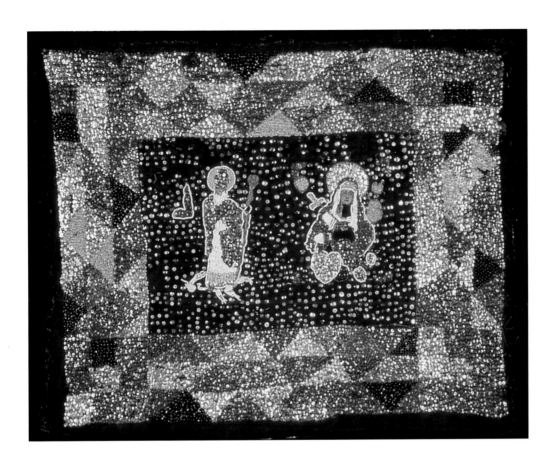

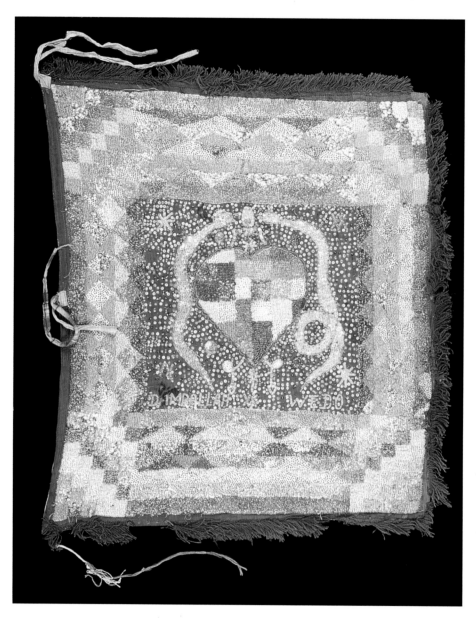

PLATE 12
Drapo for Danbala featuring her heart-shaped icon of Ezili Freda.
FMCH X88.234.

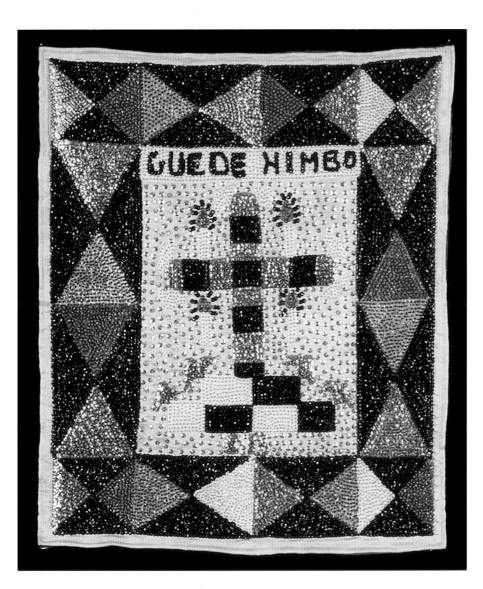

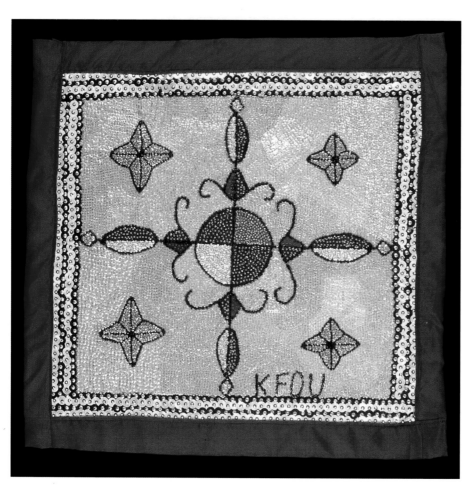

PLATE 14
Drapo displaying the vèvè
for Kafou, Legba's alter
ego, who guards the
crossroads at night.

52

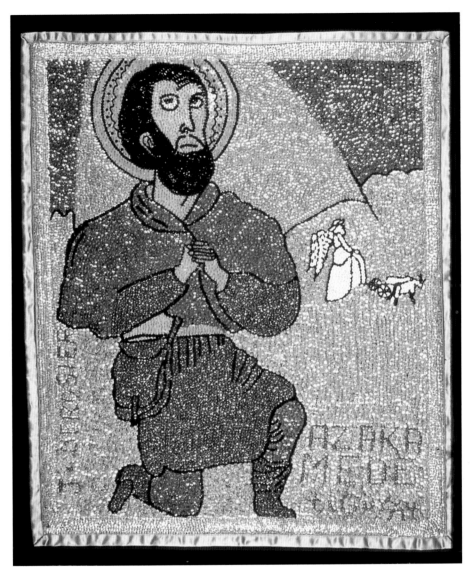

5 3

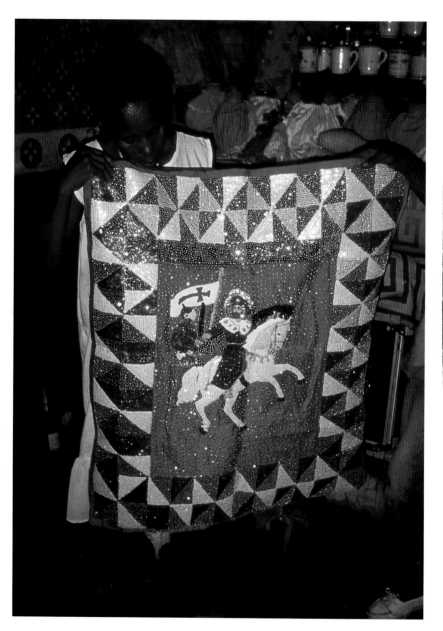

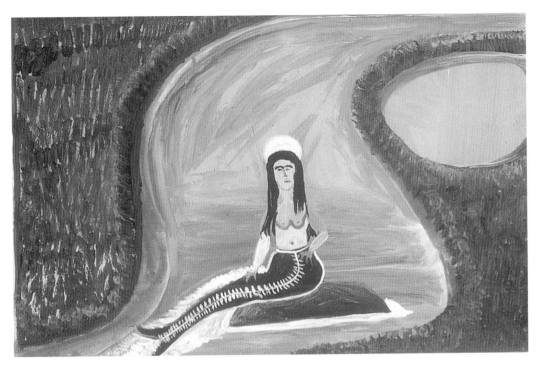

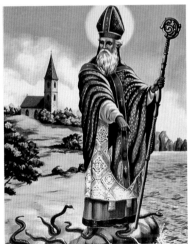

Left:
P L A T E 1 9
Chromolithograph of
St. Patrick.

Above:
P L A T E 2 0
Mermaid painted by
Canute Calliste. Carria-
cou, Grenada. 1990.

55

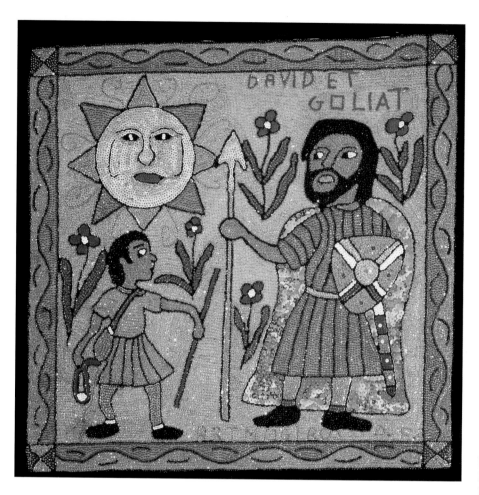

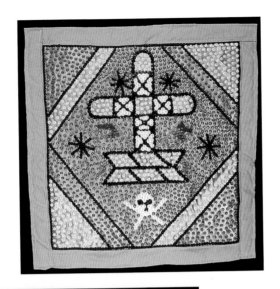

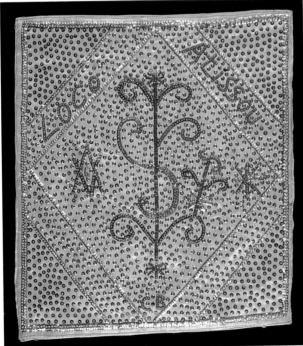

Above:
PLATE 22
A small drapo for Bawon
Samdi made for the
tourist trade.

Left:
PLATE 23
Another small flag, this
one for Loko, created for
sale to tourists.

57

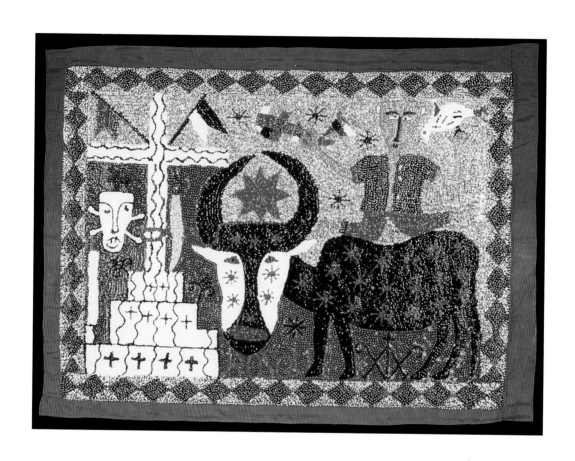

PLATE 24
Bossu (Bosou). Antoine
Oleyant. A brilliant flag
by Antoine showing the
emblem of Bosou, a
mighty bull. FMCH
X91.89.

PLATE 25
The artist Silva Joseph in front of an altar in his temple (ounfò).

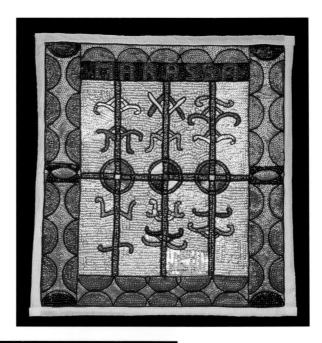

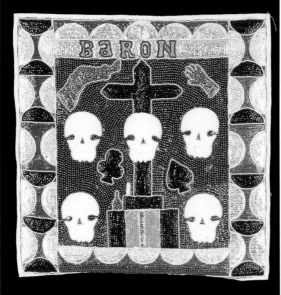

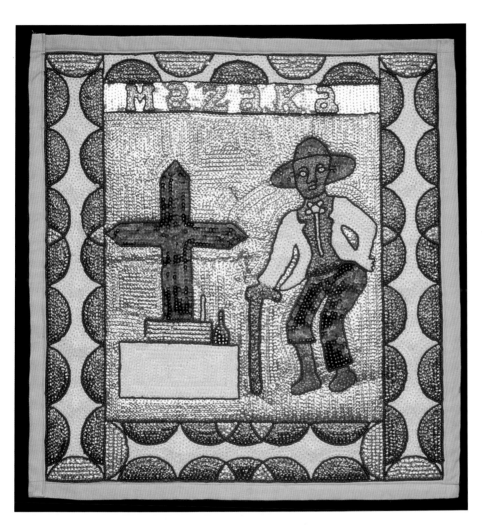

PLATE 28
Mazaka. Workshop of
Silva Joseph. Mazaka is
one of the many Gede
Iwa who govern the
cemetery. FMCH
X92.87

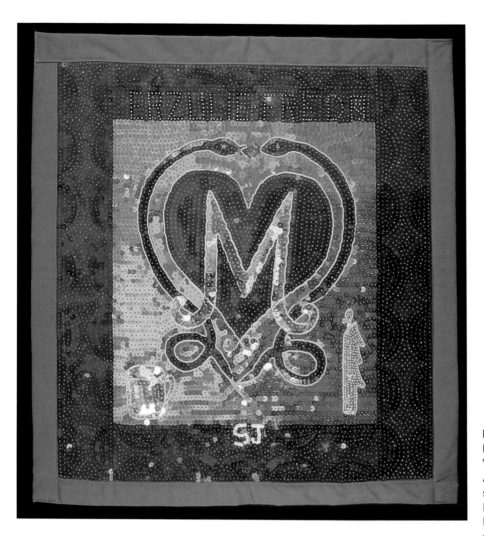

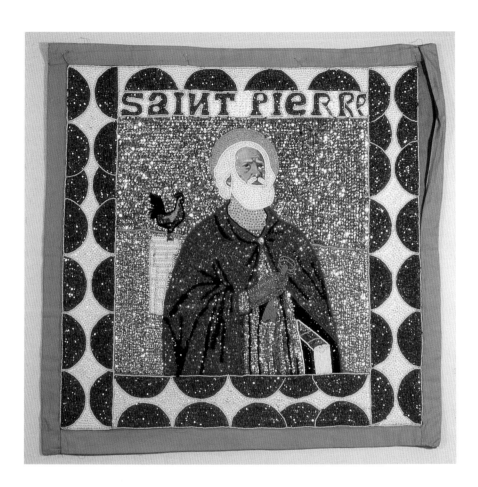

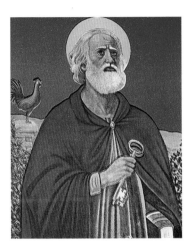

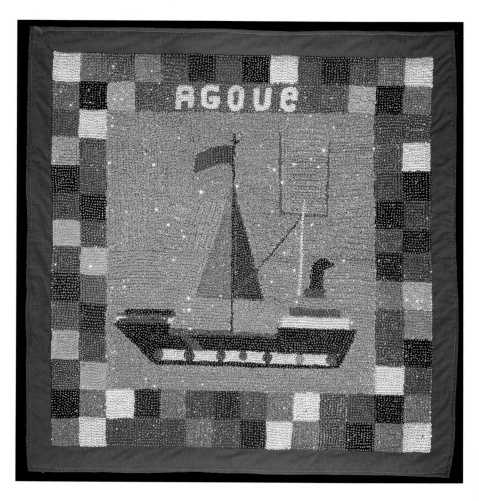

64

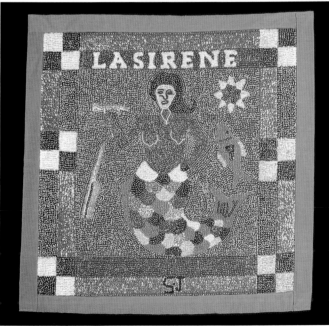

Left:
P L A T E 3 3
Lasirèn. Workshop of Silva Joseph. The enchantress from the ocean's depths, Lasirèn is usually depicted as a mermaid holding a trumpet, mirror, or comb.

Above:
P L A T E 3 4
The artist Yves Telemak outside his workshop (atilye) in the Bel-Air section of Port-au-Prince.

65

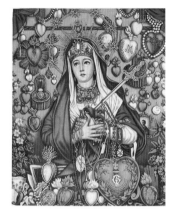

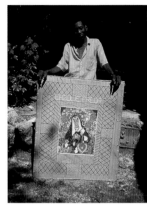

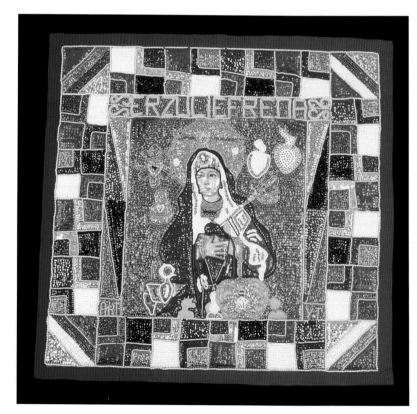

Left:
P L A T E 3 5
Ezili Freda. Yves Telemak.
The Vodou goddess of
love and beauty
interpreted as the Virgin
Mary. FMCH X94.6.8.

Above left:
P L A T E 3 6
Chromolithograph of
Mater Dolorosa
commonly used to depict
Ezili Freda.

Above:
P L A T E 3 7
Yves Telemak with a
work in progress. A
chromolithograph of
Mater Dolorosa serves as
the central motif.

66

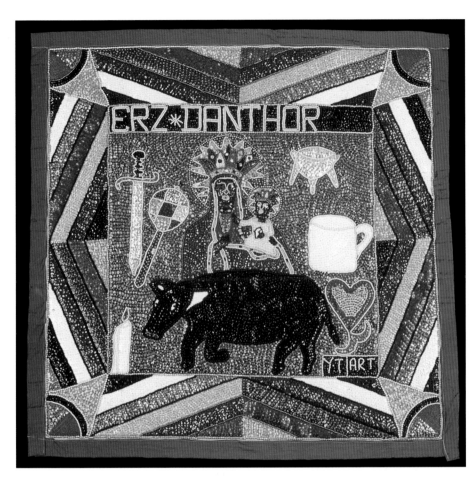

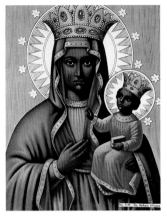

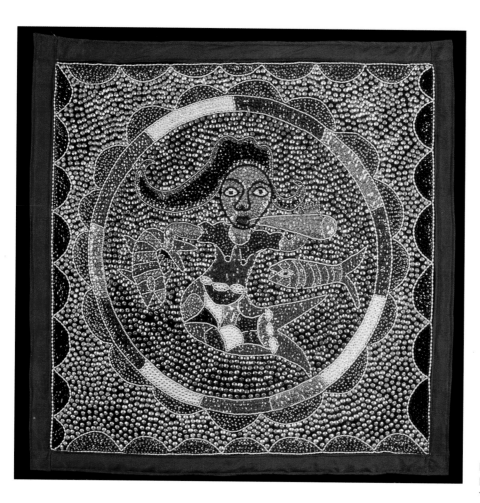

PLATE 40
Lasirèn (1990).
Yves Telemak.

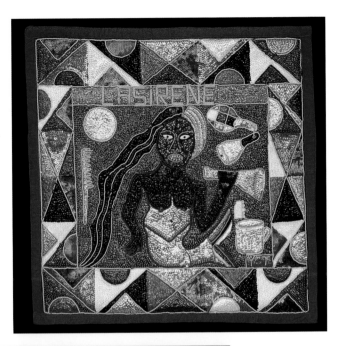

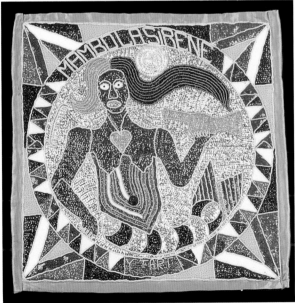

Above:
P L A T E 4 1
Lasirèn (1992).
Yves Telemak. FMCH
X93.5.3.

Left:
P L A T E 4 2
Lasirèn (1993).
Yves Telemak. FMCH
X94.14.4.

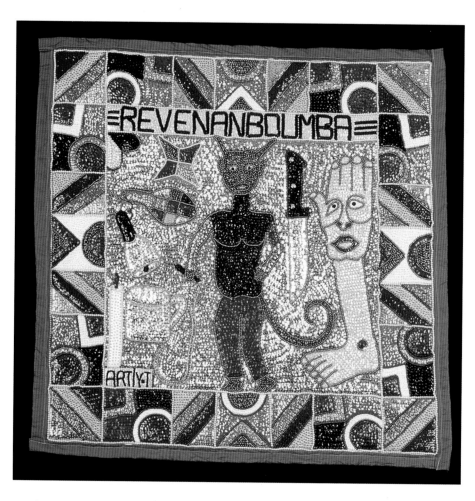

PLATE 43
Revenan Boumba.
Yves Telemak. A demon-
like specter with whom
sorcerers are said to
make their Faustian bar-
gains. FMCH X94.6.9.

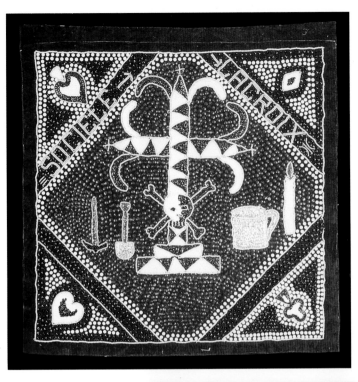

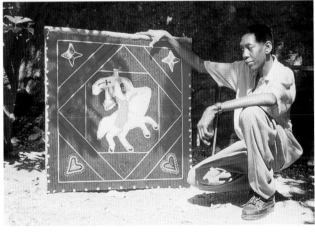

Above:
P L A T E 4 4
Societe Lacroix (Sosyete Lakwa). Yves Telemak. This work invoking Bawon Lakwa represents the "old style" of flagmaking; use of widely spaced sequins is typical of ceremonial flags (drapo sèvis) rather than of art pieces. FMCH X94.69.8.

Left:
P L A T E 4 5
Yves with an old style flag in progress.

71

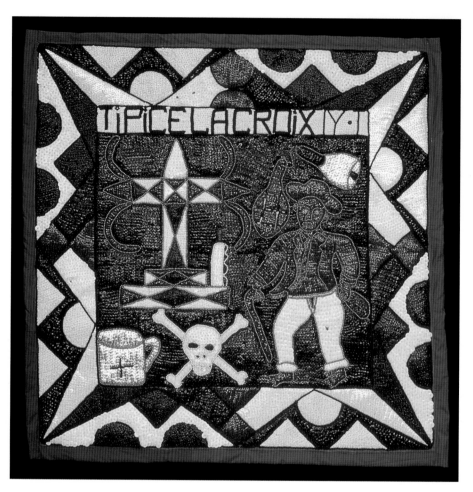

TIPICELACROIXY

PLATE 46
Ti Pice LaCroix .Yves
Telemak. A contemporary
art flag depicting Ti Pice
LaCroix, one of the many
members of the Gede
family of spirits. FMCH
X92.88.

72